LAUREL GLEN PUBLISHING

THE ART OF ANCIENT EGYPT

DAVID SANDISON

PUBLISHED IN THE UNITED STATES
BY LAUREL GLEN PUBLISHING, 1997
LAUREL GLEN PUBLISHING 5880 OBERLIN DRIVE
SUITE 400, SAN DIEGO, CA 9212

PUBLISHING DIRECTOR: LAURA BAMFORD
EXECUTIVE EDITOR: MIKE EVANS
ASSISTANT EDITOR: HUMAIRA HUSAIN
ART DIRECTOR: KEITH MARTIN
DESIGN: GEOFF BORIN
PRODUCTION CONTROLLER: MARK WALKER
PICTURE RESEARCH: CHARLOTTE DEANE

FIRST PUBLISHED IN 1997 BY HAMLYN, AN IMPRINT OF
REED CONSUMER BOOKS LIMITED, MICHELIN HOUSE,
81 FULHAM ROAD, LONDON SW3 6RB AND
AUCKLAND, MELBOURNE, SINGAPORE AND
TORONTO

PRINTED AND BOUND IN HONG KONG
LIBRARY OF CONGRESS CATALOGING-IN-
PUBLICATION DATA AVAILABLE UPON REQUEST.

MEDITERRANEAN S

DELTA

LOWER
EGYPT

•Heliopolis
■CAIRO

Saqqara•• •Memphis

EFAYUM

Gurob• •Kahun

MIDDLE EGYPT

Hermopolis

•Amarna
(Akhetaten)

Asyut•

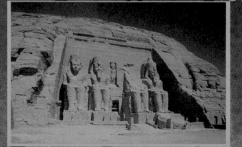

1R Cataract •Aswo

Akhmim•

UPP
EGY

WAWAT

◄ HOWARD CARTER AND HIS ASSISTANTS POISED AT THE ENTRANCE BEFORE
ENTERING TUTANKHAMEN'S BURIAL CHAMBER 1923

MYTH, ROMANTIC LEGEND AND
OF THOSE WHO PERCEIVE
MANKIND'S EARLIEST CIVILIZATIONS
EGYPT A SUBJECT OF CONTINUED
WHICH ONLY INCREASES WHEN ONE
A GLIMPSE OF THE PALACES, TEMPLES
ALL THEIR AWESOME GLORY, IN
SUCCESSIVE GENERATIONS OF
AN INTERNATIONAL BRIGADE OF
ATTEMPTING TO RECOVER AND
PLAGUES OF AIR POLLUTION

THE MORE OUTRAGEOUS CLAIMS EXTRATERRESTRIAL INFLUENCES ON HAVE HELPED MAKE ANCIENT FASCINATION. IT IS A FASCINATION IS FORTUNATE ENOUGH TO CATCH AND TOMBS WHICH STAND, IN THE VARIOUS MAJOR SITES WHICH ARCHAEOLOGISTS HAVE UNCOVERED AND CONSERVATIONISTS ARE NOW PROTECT FROM THE MODERN AND TOURIST-CREATED EROSION.

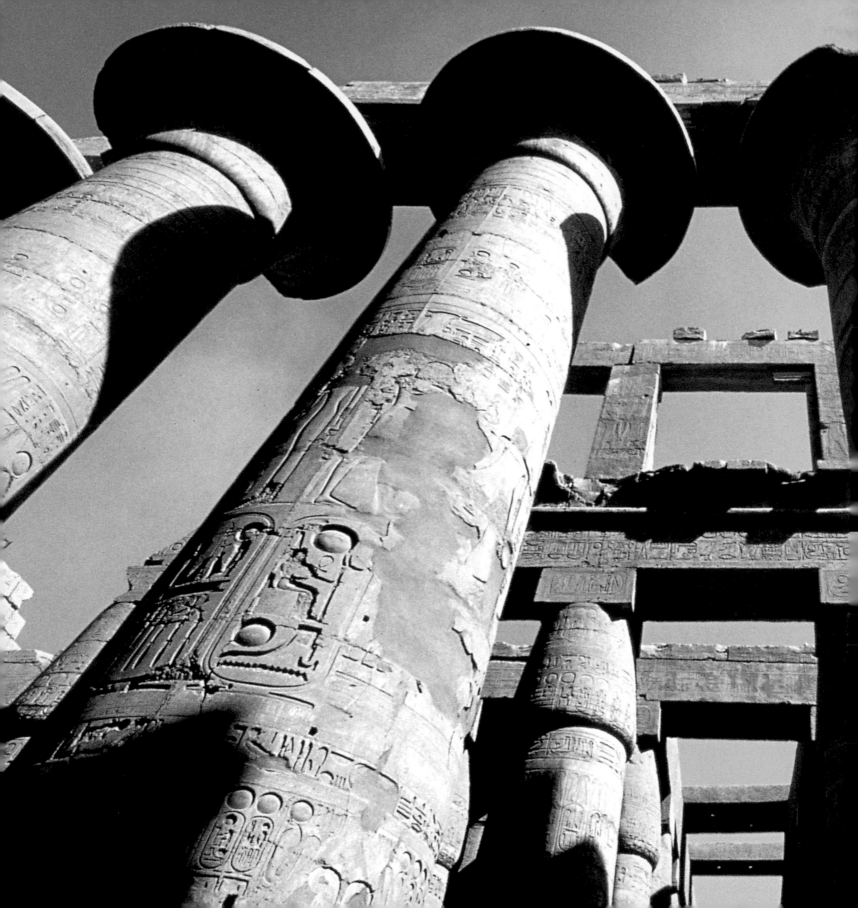

N othing can prepare the modern visitor for the impact of seeing these sites 'in the flesh', whether it be the best photographs, film or TV documentaries or even visiting the many museums which boast Egyptian antiquities in their collections. These sources provide only second-hand impressions, mere fragments of the glorious reality which simply takes one's breath away.

It's not only the immense scale of those buildings that have been painstakingly rescued from the sand which buried them when a major climate change altered a once-temperate region into a vast desert, though that is guaranteed to revise one's perception drastically. The real impact comes when one walks between towering columns or along the twisting corridors inside a tomb and realizes that every inch of space has been filled with exquisite carvings and paintings to create a dazzling mosaic of images of a long-lost age—images which are guaranteed to remain locked in one's mind and continue to stir the imagination.

That they have survived at all is something of a miracle, for much of the pharaohs' treasure was thoroughly plundered through the ages—initially by Egyptian peasants (despite dread curses and the threat of severe punishments), then by successive occupying forces in the centuries which followed the fall of the Egyptian Empire, the rise of Christianity and the region's subequent collapse into a barely-controlled anarchy.

The worst and most systematically organized excesses occurred during the late 18th and 19th centuries when treasure-hunting adventurers descended on Egypt, only too aware that there was an unlimited and lucrative world market for antiquities. Pyramids and tombs were dynamited to gain access to the treasures within and many a distinguished academic establishment owes its Egyptology collection to the brutal use of crowbars and battering rams which indiscriminately smashed their way through what these vandals considered worthless trifles—including irreplaceable funerary artefacts and those everyday objects laid reverently in place to accompany the tomb's occupant into the afterlife, unique manuscripts and the small mummies of children and animals.

Gold leaf was torn from mummy cases, limbs were ripped from bodies and set alight to illuminate rooms about to be plundered. Confronted by a passage filled with bodies thousands of years old, the robbers would casually toss them aside or smash them into dusty fragments to create a pathway to the next chamber. It was an incalculable loss and few of those who participated in this orgy of barbaric vandalism come out of it with any credit—and that includes the museum curators of the day who asked few questions when a new cache came on the market. Acquisition was everything and eyes were carefully averted from the desecration and destruction implicit in such expeditions.

Along with the natural inclination of intervening generations of ordinary Egyptians to utilize the stones of pyramids, temples, and tombs to create their own homes and villages, it is remarkable that anything of worth or substance survived, but a clamp-down on the looters, the founding of the Cairo Museum and a stricter allocation of licences to foreign archaeologists would reduce the worst excesses and allow more sensitive work to begin in the last quarter of the 19th century.

◄ **K A R N A K T E M P L E**
EVERY INCH OF SPACE ON THE TOWERING COLUMNS OF THE KARNAK
TEMPLE WAS FILLED WITH EXQUISITE CARVINGS AND PAINTINGS TO
CREATE A DAZZLING MOSAIC OF IMAGES.

▶ VALLEY OF THE KINGS

A "CITY" OF TOMBS, THE REMOTE AND FORBIDDING VALLEY OF THE KINGS WAS AN ATTEMPT BY GENERATIONS OF EGYPT'S RULERS TO EVADE THE ATTENTIONS OF LOOTERS.

In 1871 a goatherd stumbled on a treasure-filled tomb complex which was eventually identified as containing the bodies of some of the greatest pharaohs of the New Kingdom's 17th, 18th, 19th, and 20th Dynasties—including Seti I and his son, Ramses II, known as "the Great," Thutmosis III and Amenhotep I, the High Priest of Amen who had risen to become vizier and lord of the whole Egyptian empire in the 11th century BC.

In time, further excavations would uncover an entire "city" of royal tombs which would earn the remote locality the title Valley of the Kings. The enormous site was a fairly successful attempt by the rulers of that time to store themselves far away from the unwanted attentions of contemporary and future looters and, with its neighboring Valley of the Queens and Valley of the Nobles, constituted the greatest repository of Egyptian antiquities and art available to the new breed of more reverent and scholarly archaeologists.

Most of those artifacts were removed from their resting places—some to museums and other academic institutions, and many others to the black market which continued to thrive (and exists to this day) despite the best endeavors of Egyptian lawmakers and enforcers. Many *stelae* (carved slabs) were removed, as were statues and plinths, elaborately carved doors, painted wooden panels, and even stone columns.

What was left intact and in situ was the vast bulk of wall paintings and hieroglyphs which adorned those sites so lavishly. Painted floors could be lifted and moved with relative ease, but it was almost impossible to remove those which teams of court artists had painstakingly applied to the walls of temples, palaces, and tombs. Almost, but not entirely, however, and the examples of wall art which now rest in the world's museums are remnants which stand in mute testimony to the smash-and-grab methods often used to extract them. Just as unforgivable is the puritanical censorship which led some early Western visitors to deface or destroy some sections of paintings which depicted uncovered male genitalia—atrocities which, paradoxically, draw the contemporary visitor's eyes to those sections every bit as unerringly as a sex-and-violence controversy is guaranteed to increase public interest in a book, play, or movie!

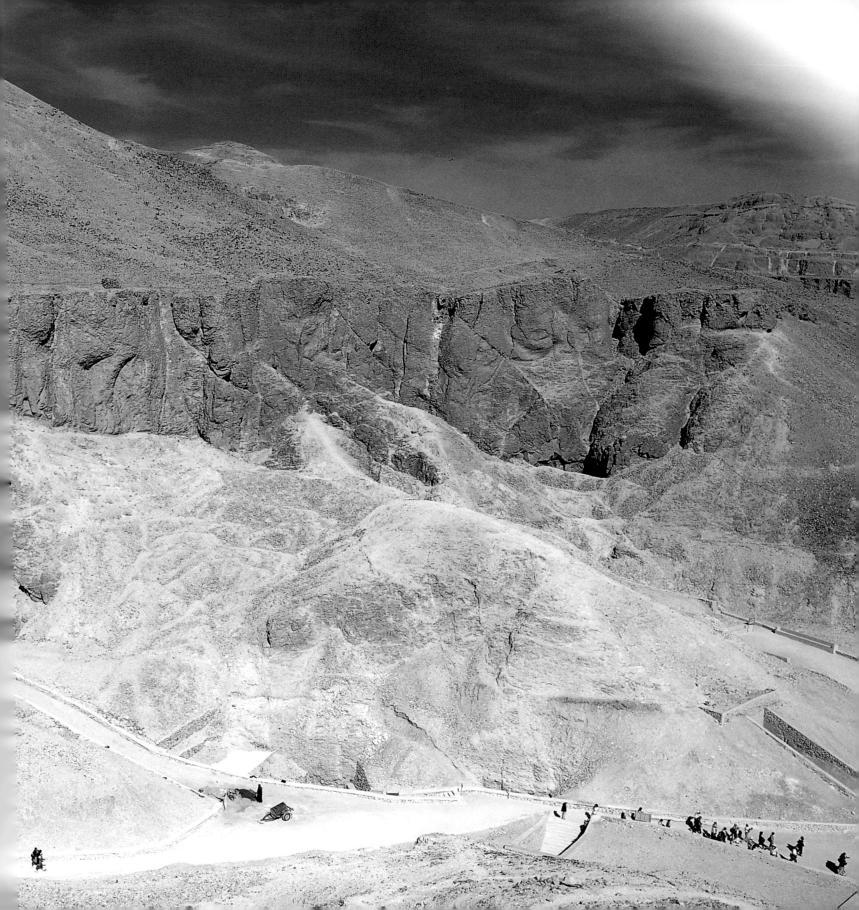

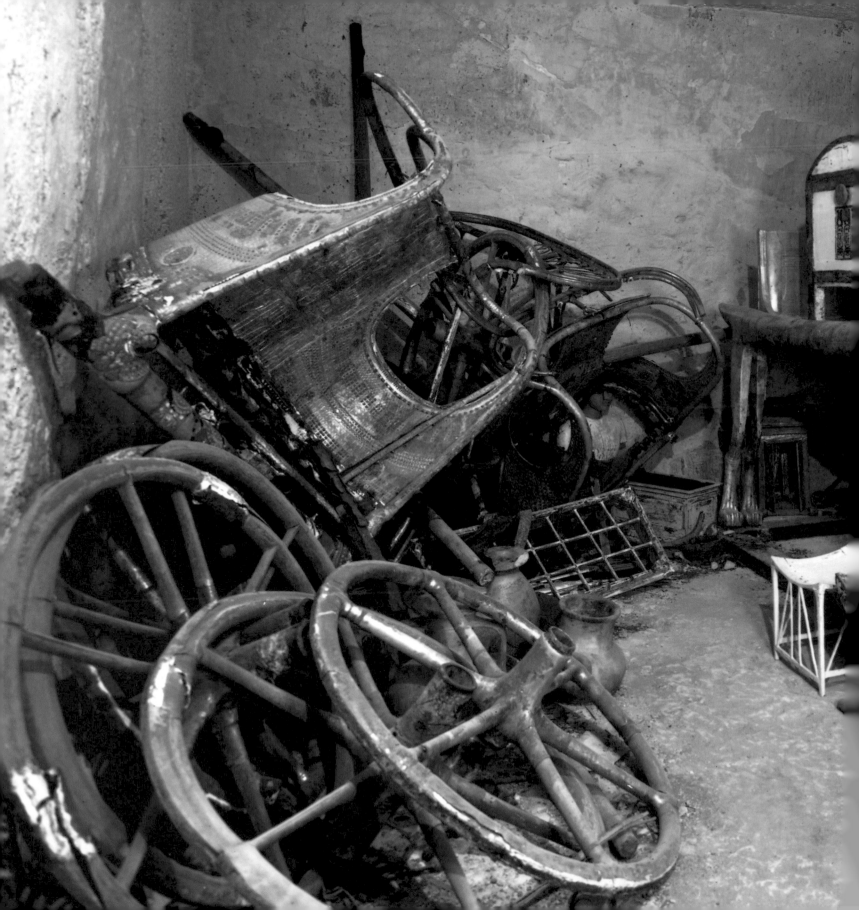

The wealth of surviving material to be found in The Valley of the Kings (known to ancient Egyptians as "The Great Place"), the Valley of the Queens ("The Place of Beauty"), the Valley of the Nobles, and the nearby Valley of the Artisans (final resting place for many of those who executed or supervised the creation and decoration of the royal tombs, palaces, and holy temples) offers a wonderful insight into a long-lost world where kings and queens reigned as gods and goddesses over a fabulous civilization which was in decline when most other world societies were struggling through the birth pangs which would take them from the chaos of tribal warfare to something resembling form, order, and nationhood.

The discovery and excavation, in 1922, of the intact burial chamber of the 18th Dynasty boy king Tutankhamen typifies the hold which ancient Egypt continues to have on the outside world. Aided, in part, by fanciful stories of dread curses and misfortunes which dogged those who took part in the excavations led by Howard Carter and Lord Carnarvon, the young ruler's tomb—and its treasure trove of artifacts and funerary art—became the jewel in Egyptology's crown and Tutankhamen the ruler whose name is probably the best-known to the average man, or woman, in any street you care to poll.

While the contents of Tutankhamen's tomb are outstanding, they represent only the tip of the artistic riches which have been discovered, retrieved, and saved for posterity. Not least among these are the painted reliefs, murals, and hieroglyphs created by Egypt's master craftsmen thousands of years ago. As historical documents they are an invaluable source of information. The greatest bonus for us, of course, is that many of them are also exquisitely beautiful.

◄ **TUTANKHAMEN'S CHARIOTS**

THE SOUTHERN END OF THE ANTECHAMBER OF TUTANKHAMEN'S TOMB WAS FULL OF CHARIOTS AND FURNITURE. DISMANTLED, THE CHARIOTS WERE READY FOR REASSEMBLY IN THE AFTER-LIFE.

13

One of the first objects encountered in London's British Museum's ground-floor gallery of Egyptian artifacts is a large slab of black basalt weighing almost 1,680 lb. and measuring c. 30 in. wide, 46.5 in. high and 12 in. thick. Covered by three distinctly different forms of writing carved into its face, this is the world-famous Rosetta Stone, a relic whose successful translation in 1822 enabled generations of Egyptologists to unravel the history of a civilization whose early origins and progress had—until then—been confused by generations of hit-and-miss guesswork.

More importantly, perhaps, the deciphering of the hieroglyphs found on the Rosetta Stone would transform the ways in which scholars could view the mass of wall, floor, and ceiling paintings, carved reliefs, statues, and papyrus documents which the excavation of Egypt's many temples and tombs revealed. In simple terms, the hieroglyphs were the storyline captions which made those paintings and reliefs much more than exquisite decorative art.

The most puzzling aspect of the quest to unravel the mysteries of hieroglyphs (Greek for "sacred carvings") is the fact that it took so long for the first accurate translations to be made. The decline and demise of Ancient Egypt coincided with the inexorable rise, influence, and domination of the Greek and Roman empires, both of whose writing styles were markedly different from the ancient Egyptian, which used pictorial images to represent only the consonants of words and omitted any indication of vowels or tenses. Nevertheless, such was the overwhelming influence of Egypt (either by trade or political domination) over great areas of the known Western world—including the adoption by Roman emperors and generals of the Egyptian cartouche, an unbroken line "framing" the names of kings or queens to symbolize their absolute power—it's astonishing that no accurate translation was made until the 19th century, despite many attempts having been made during the intervening years. The root of the problem lay in the mistaken belief that hieroglyphs were not "everyday" writing but symbolic, secret, and esoteric; to translate them you needed to have an intimate knowledge of religious cults which had been obliterated by the rise of Christianity but were, in any case, shrouded in mystery and secrecy before Alexander the Great colonized Egypt more than 300 years before the birth of Christ. They were nothing of the sort. They were the everyday writing of their time and only fell into disuse when Egypt began to be exposed to other, more accessible and easily learned forms of written communication. Indeed, Egyptian hieroglyphs are now recognized as the world's oldest recorded language system (with the possible exception of Sumerian), with the earliest texts dating from the end of the fourth millennium B.C. The Rosetta Stone was the key which opened the door to shed light both on a long-lost civilization's way of life and the wealth of ancient Egyptian art which would be reclaimed from the dust and sands of time.

▲ JEAN-FRANÇOIS CHAMPOLLION
THE BRILLIANT FRENCH SCHOLAR WHO FIRST TRACED THE LINKS BETWEEN ANCIENT HIEROGLYPHS AND MORE MODERN LETTERS. A PAGE FROM HIS ORIGINAL TREATISE IS REPRODUCED ON THE TRACING PAPER, OPPOSITE.

▶ ROSETTA STONE
A LARGE SLAB OF BLACK BASALT NOW HOUSED IN THE BRITISH MUSEUM, THE ROSETTA STONE WAS THE KEY WHICH CHAMPOLLION AND OTHER SCHOLARS USED TO UNLOCK THE MYSTERY OF EGYPTIAN HIEROGLYPHICS.

Lettres Grecques	Signes Démotiques	Signes hiéroglyphiques
Α		
Β		
Γ		
Δ		
Ε		
Ζ		
Η		
Θ		
Ι		
Κ		
Λ		
Μ		
Ν		
Ξ		
Ο		
Π		
Ρ		
Σ		
Τ		
Υ		
Φ		
Χ		
Ω		
ΤΟ		

Lettres Grecques	Signes Démotiques	Signes Hiéroglyphiques
A		
B		
Γ		
Δ		
E		
Z		
H		
Θ		
I		
K		
Λ		
M		
N		
Ξ		
O		
Π		
P		
Σ		
T		
Υ		
Φ		
X		
Ψ		
Ω		

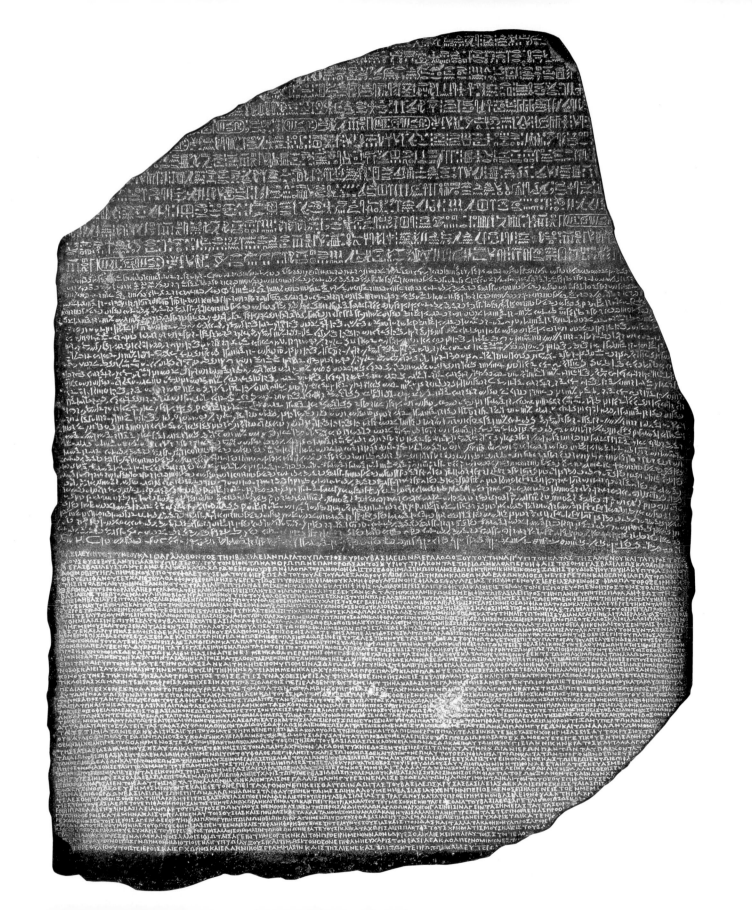

Discovered in 1799 by French soldiers digging for a fort being built near the town Rashid, on the site of the city of Rosetta which stood on the west branch of the Nile near the Mediterranean, the stone is now known to have been a commemorative stela (decorated slab) once set in a temple. From the text—the three sections consisted of hieroglyphs, Demotic (Arabic) and Greek—it was found that it had been erected in the ninth year of the reign of Ptolemy V Epiphanes. That dated it from 196 B.C.

Copies of the texts were sent to European scholars for them to work on translations. The stone and other antiquities were granted to Britain under the Treaty of Alexandria in 1801 and shipped to the British Museum a year later. It was simple enough to match the Greek and Demotic passages, but early attempts to translate the hieroglyphs led to understandable errors, some very wide of the mark.

Credit for breakthrough lies with brilliant French scholar, Jean-François Champollion. Research by others confirmed a link between the Demotic script and some hieroglyphs, especially cartouches which referred to King Ptolemy—to produce "modern" letters, as well as hieroglyphs on the base of an obelisk including the names of Ptolemy and Cleopatra. Using these as a start, Champollion concentrated on other cartouches and soon formed the beginnings of an accurate phonetic alphabet which could be extended back to earliest times, even if some symbols had changed. Context alone solved that problem. With hindsight it is easy to see how later languages, notably the Canaanite/Phoenician and early Greek, adapted and adopted hieroglyphs to their own alphabets, which in turn became modern Greek and Latin.

Armed with this knowledge, the historians, archaeologists, and explorers drawn to the land of the pharaohs could now make sense of the glorious art they found. As beautiful as they were, the paintings covering almost every surface of pyramid, temple and tomb, were no mere decorations. In conjunction with the "captions" supplied by the hieroglyphs, they brought the history of ancient Egypt vividly to life. They tell of great adventures, triumph and disaster, gods and goddesses, heroes and priests. They depict the minutiae of life in the king's court, the ranking of dignitaries and courtiers. They reveal the complex hierarchy of their religions and everyday tasks undertaken by mortals trying to eke out a living.

The hieroglyphs and paintings of ancient Egypt are both great art and a fascinating source of information, even if it is surely as biased as a modern "official" biography today. Despite the ravages of time and climate—and the vandalism of robbers and inept archaeologist—that art speaks to us over the centuries to describe, in often stunning detail, a lost civilization which has few historical peers.

▶ **PAPYRUS**
WRITINGS ON PAPYRUS, LIKE THIS MATHEMATICAL TREATISE, CONTINUE TO
PROVIDE EGYPTOLOGISTS WITH A MINE OF FASCINATING INFORMATION.

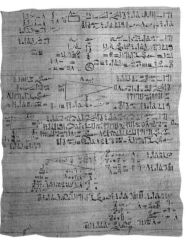

◀ **"WHITE CHAPEL"**
A TRIUMPH OF THE STONEMASON'S ART, THE HIEROGLYPHS CARVED INTO
THE SANDSTONE OF THE SO-CALLED "WHITE CHAPEL" OF SESOSTRIS I
(C. 1950 B.C.) ARE A DEDICATION TO AMEN-MIN, GOD OF FERTILITY.

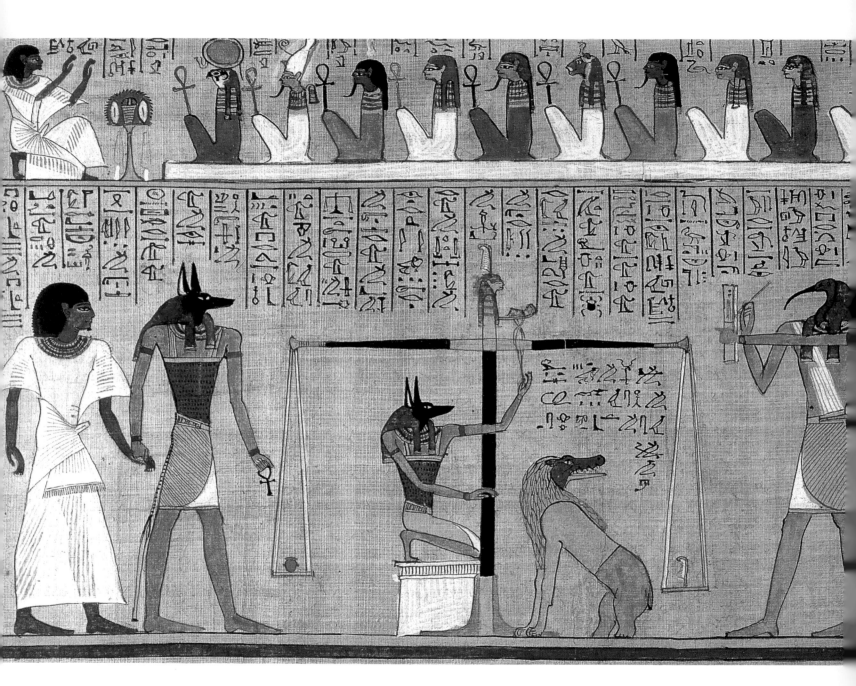

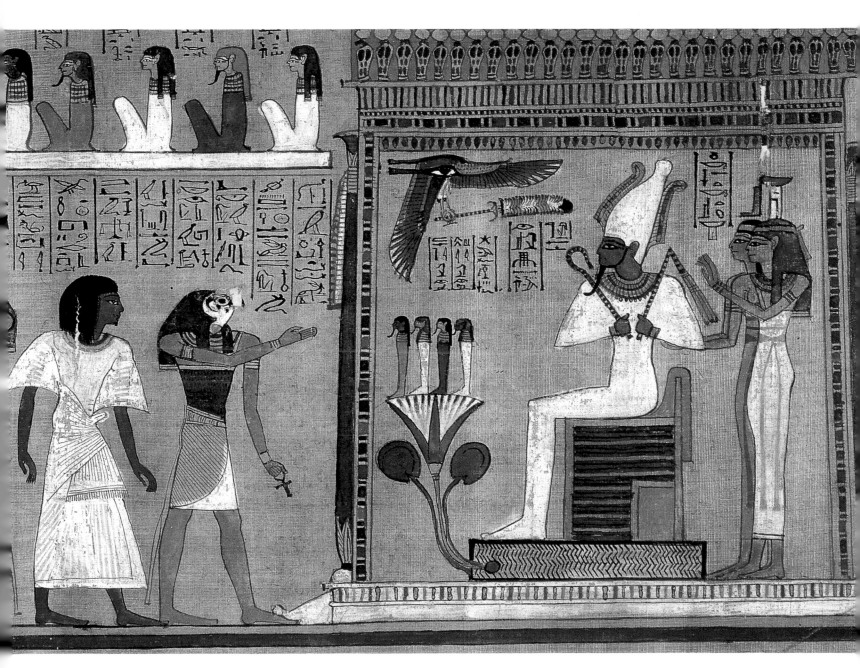

▲ BOOK OF THE DEAD

DETAIL FROM THE BOOK OF THE DEAD OF HUNEFER, A ROYAL SCRIBE AND STEWARD OF THE 19TH DYNASTY (C. 1320-1290 B.C.). A SUPERB BLEND OF LINE AND COLOR WAS USED BY THE PAINTER OF THIS SCENE, WHICH SHOWS HUNEFER (IN WHITE) BEING BROUGHT TO JUDGMENT BY ANUBIS BEFORE THE FALCON-HEADED HORUS LEADS HIM INTO THE PRESENCE OF OSIRIS (RIGHT). THE FIGURES DEPICTED AT THE TOP ARE A PANEL OF JUDGES DETERMINING HUNEFER'S SUITABILITY FOR ADMITTANCE INTO THE NEXT WORLD.

N o system of two-dimensional representational art boasts an earlier inception or longer duration than the one which, despite various developments and changes, remained distinctively Egyptian in character from the Early Dynastic Period (c. 3000 B.C.) until the final decline and elimination of the pharaohs almost three full millennia later.

Given the remarkable engineering feats achieved in ancient Egypt (the pyramids at Giza were well over a thousand years old when Tutankhamen came to the throne) and the consummate skills employed to create much of their art, it is puzzling that the Egyptians did not take the next most obvious step, to discover or employ perspective in their carved reliefs and paintings. They made three-dimensional statues, after all, so why not pictures as well? While understandable, this question is based on a fundamental misunderstanding of Egyptian art, the basic principles of which were completely different from modern artistic conventions.

▶ RE-HARAKHTI

A *STELE* (CARVED STONE SLAB) OF A WOMAN IN SUPPLICATION BEFORE A TABLE OF OFFERINGS FOR THE GOD RE-HORAKHTY. THE STREAMS OF FLOWERS SHOWN REPRESENT THE RAYS OF THE SUN.

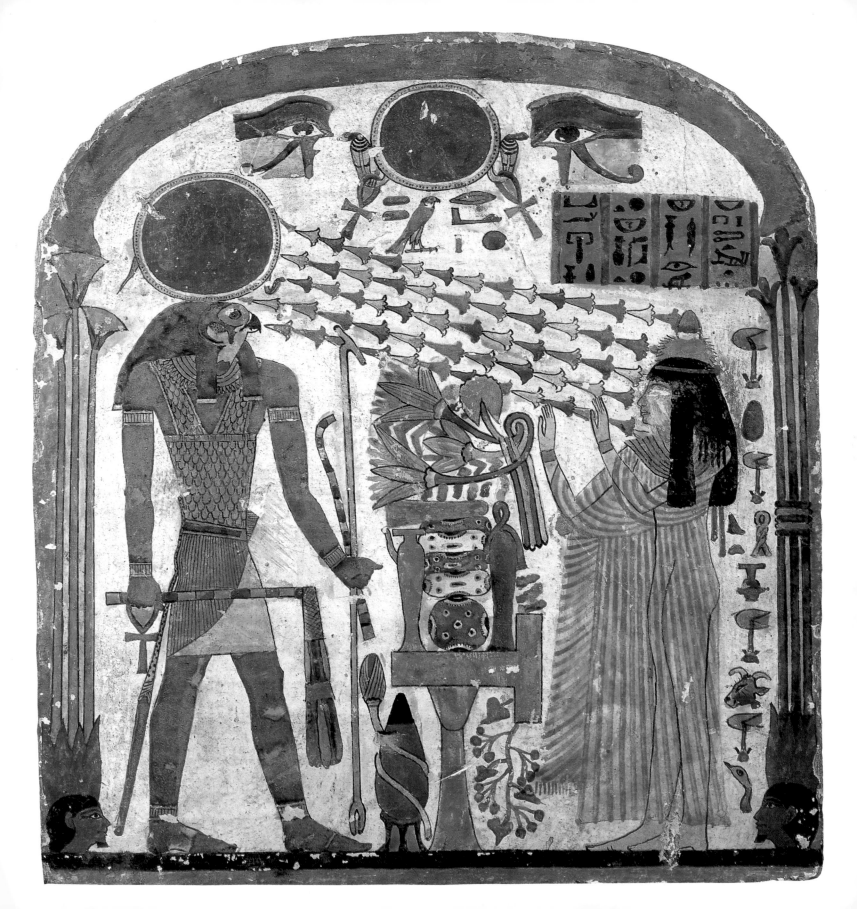

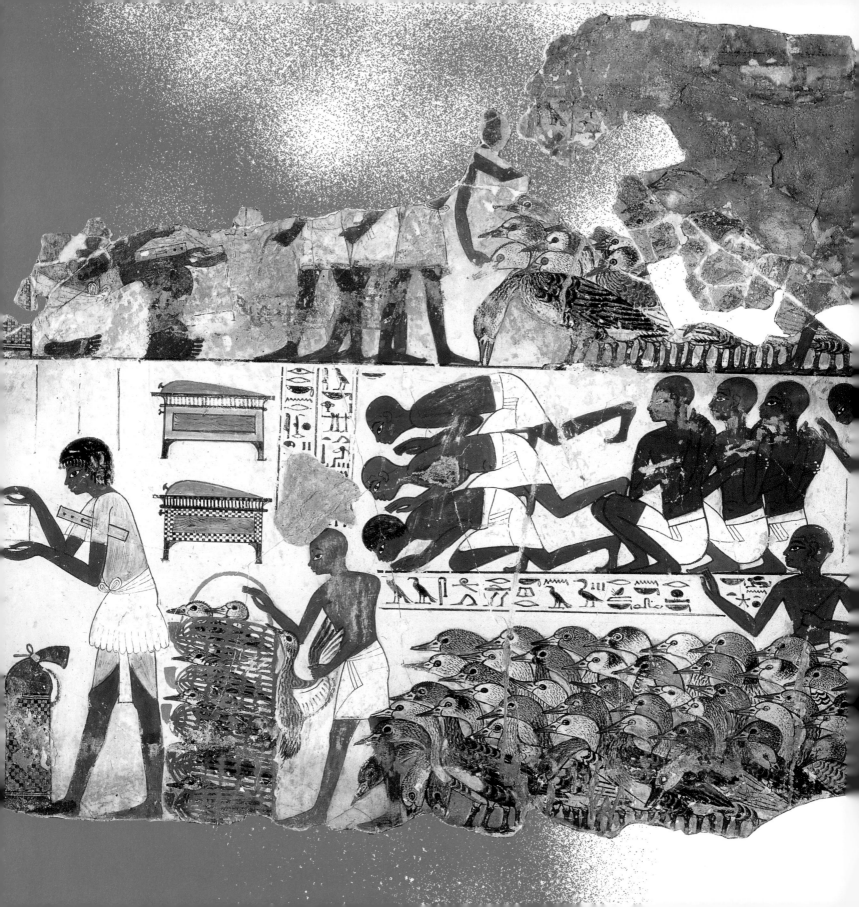

One has to begin by accepting that, in formal settings at least, the Egyptians used drawings of objects and figures as diagrams of what they represented, so communicating an objective "truth." They had to be instantly comprehensible and totally unambiguous, regardless of the passing of time. Subjects were represented in what the Egyptians regarded as their "real" forms, so there was no need—or place—for anything as potentially ambiguous or distorting as perspective, which could have given a misleading central viewpoint for a complicated picture in which an overall concept was the single most important objective, not the artist's perception.

It is also important to remember that the Egyptians did not create art for its own sake. The reliefs and murals which we now regard as works of artistic brilliance were produced mainly to fulfill specific religious or everyday functions. In the case of tombs and temples, such work had a definite ritual purpose in depicting the tomb owner, kings, and deities in the eternal and abstract worlds of the gods and the afterlife. That said, they did bring a greater vivacity and freedom to subsidiary scenes that depicted the world the tomb-owner had left behind, even if these still stuck to age-old traditions that prescribed how most subjects and scenes were portrayed.

Inanimate objects were traditionally depicted in profile. Stools and chairs, for example, are invariably shown with two legs and no depth. Where the seat does appear, it is as a rectangle above the profile but on the same plane. Rectangular objects, like boxes or chests, were represented from the front or side, their contents drawn above. A view from above was used in the case of objects with breadth but little depth—animal skins, for instance, plates, sandals, or scribes' palettes.

◄ COUNTING GEESE

PORTRAYALS OF A TOMB-OWNER'S LIFE INVARIABLY INCLUDED DETAILS OF HIS DAILY ROUTINE. THIS FRAGMENT OF A WALL PAINTING FROM THE TOMB OF NEBAMUN, IN THEBES, SHOWS A SCRIBE CARRYING OUT A GOOSE CENSUS ON HIS MASTER'S ESTATE. TUCKED UNDER HIS ARM IS A WRITING PALETTE, WHILE THE CYLINDRICAL BASKET AT HIS FEET WOULD HAVE CONTAINED PAPYRUS ROLLS. THE ARTIST USED GREAT SKILL AND REMARKABLE CARE TO DEPICT THE GEESE INDIVIDUALLY.

When it came to the human figure, the rules were strict—and strictly adhered to, for the most part. Humans were represented by a stylized composite of what was considered the "typical" aspect of each section.

Thus, the head was drawn in a profile which showed a half mouth and one full-view eye and eyebrow. While the shoulders were shown full-width from the front, the torso—from armpit to waist—was depicted in profile, as were the elbows, waist, legs, and feet. For the greatest part of the Pharaonic period, the arches of both feet were visible (a physiological impossibility), but during the reigns of Thuthmosis IV and Amenophis III—roughly between 1505 and 1372 B.C.—a few attempts were made to portray the "near" foot from the outside, displaying all five toes. Initially reserved as a distinguishing mark for rulers and their immediate families, it only became the common form of representation during the Ptolemaic period a full millennium later.

Hands were usually depicted full view, whether clenched or open. When they were open, they were seen from the back with the nails visible. When clenched they could be shown from the back (with knuckles visible) or the front (with fingernails on view). A strict conformity to these standard representations often led to what we would perceive as mistakes—when a standing figure was shown with arms down and hands open, the hands were depicted identically so that the far hand's thumb is on the side of the hand away from the body. This didn't happen with clenched fists, probably because they could be shown either from the back or front.

▶ SERVING GIRL

A SCANTILY CLAD GIRL FROM THE FAMILY OF REKHMIRE, A COURT OFFICIAL UNDER BOTH THUTMOSIS III AND AMENOPHIS II, SERVES GUESTS IN A BANQUET SCENE FROM HER MASTER'S TOMB.

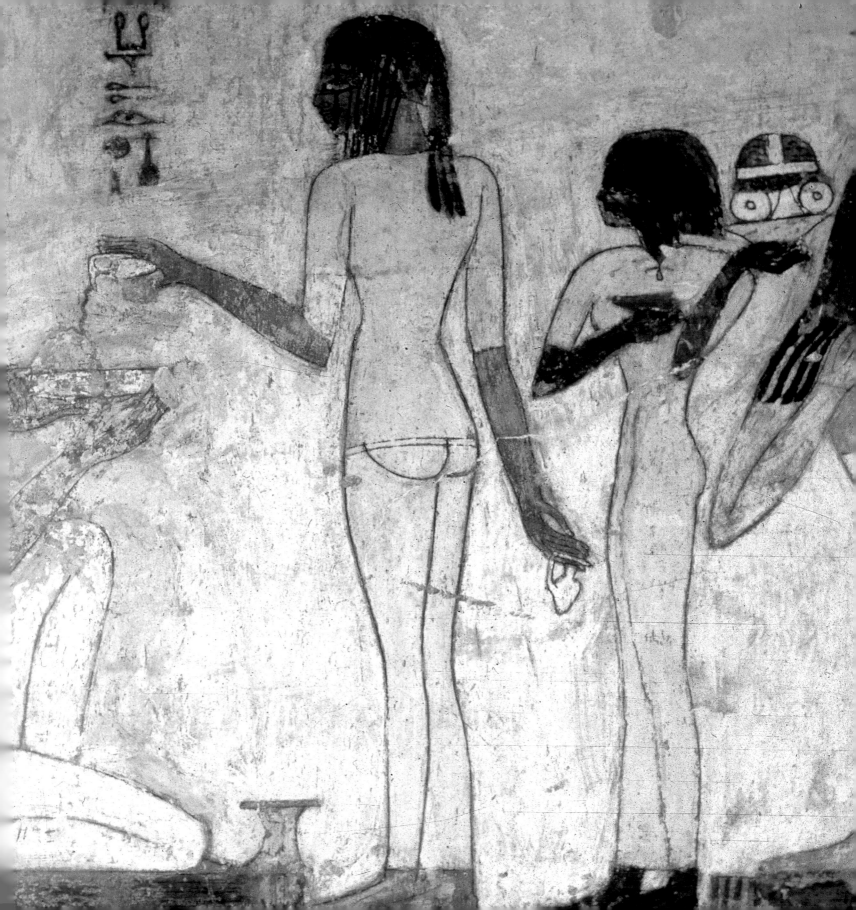

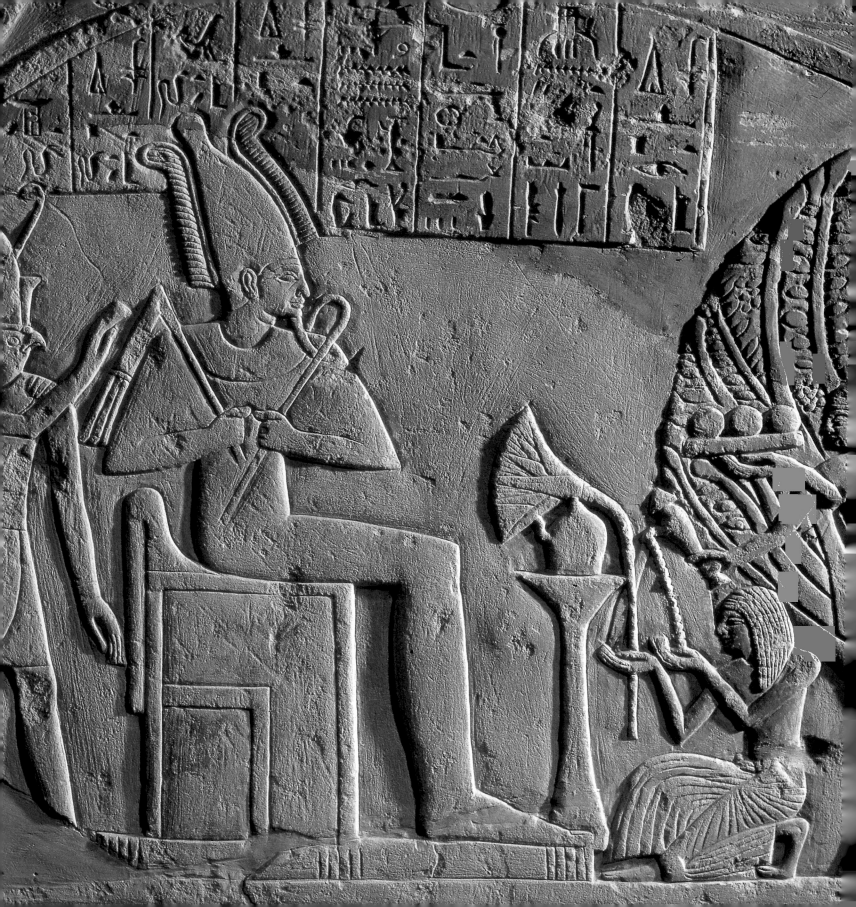

▼ JUDGMENT OF NEFER-IS

DETAIL FROM THE PAPYRUS BOOK OF THE DEAD OF THE LADY NEFER-IS, IN WHICH SHE IS SHOWN AWAITING JUDGMENT AS HER HEART IS WEIGHED AGAINST THE TRUTH. AWAITING HER, ON THE RIGHT, ARE THE DEITIES OSIRIS, ISIS, AND NEPHYTYS.

The confusion did not end there. In life, certain objects were held with a specific hand (according to Old Kingdom statues, a long staff in the left hand, for instance, with a short scepter held next to the body with the right hand). In two-dimensional figures facing to the observer's right, that gave artists no problem—the staff was placed in the left hand, which was the forward one, and the scepter in the other, rear one. When figures were portrayed looking left, logic suggests that the arm bearing the staff should become the rear one and the scepter the forward.

However, to avoid the staff running across both the body and the scepter, the artists continued to position it in the forward arm, which would make it the wrong one. To keep objects in the "correct" hands, a left hand would be added to what would, in real life, be the right arm, and a right hand to the rear arm. Finally, and just as confusingly, a left-facing figure could be shown with the scepter passing behind his body regardless of whether it was depicted being held in the left or the right hand! If you keep in mind that what you see are not hands as they would appear in life, but symbols of hands, those Egyptian artists had not made mistakes—they'd merely chosen to represent them that way.

The importance of representing figures in the correct order of rank and influence was crucial. We know from statue groups that it was customary for women to sit on the left of their husband, father, or son. In two-dimensional works the man's superiority was indicated easily by placing his figure in advance of the woman's. When the woman is shown embracing the man in left-facing scenes, she uses her right arm. However, when the couple are shown facing right, her right arm would become the rear one and if she were to be shown using the other forward arm, the man would lose his position in front. The woman, therefore, must embrace him with her forward arm, which gives the impression that she is also on the man's right.

The solution to this quandary was fiendishly simple: in right-facing groups, the man's position on the right was indicated by placing the heel of his foot over the toes of the woman (if they are standing), or his buttocks over her knees (if they are seated). Again, while the result may be a visual and physiological mess to the modern observer, it is absolutely logical in Egyptian artistic terms.

Rank was also distinguished by the actual size of images, so the larger a figure was depicted, the greater its importance. When scenes depict kings with deities, there is little to choose between them, which is only natural since they were generally considered to be equals.

◄ STELA OF KAMOSE

THE GODDESS OF THE SYCAMORE TREE GIVES WATER TO THE DEAD KAMOSE WHILE HE OFFERS SACRIFICE TO HORUS, OSIRIS, ISIS AND HATHOR. A SUPERB DETAIL FROM A *STELA OF KAMOSE*, WHO LIVED DURING THE NEW KINGDOM (C. 1200 B.C.).

▲ AT WORK

MEN TOIL IN THE FIELDS OF MENNA, ESTATE MANAGER FOR THUTMOSIS IV
(C. 15TH CENTURY BC), IN A TOMB SCENE FOUND IN WEST THEBES.

During the Early Dynastic Period artists began to order what had previously been randomly scattered figures and came up with a division of the drawing surface into horizontal registers. However, these were never designed to indicate pictorial depth (by placing far-away objects in upper registers), spatial relationships between the different registers, or to supply any information about the chronology of the different scenes they included. Unlike a modern cartoon strip, there does not seem to be a specific order in which they should be read.

The lower line of each register was used as a ground line for all figures within it, and even when these overlapped to give an impression of depth (processions of people, herds of beasts, flocks of birds), all their feet were placed firmly on that line so that the true spatial relationship between figures was not represented.

Artistic license was used to escape from the rigidity of the registers in desert and battle scenes. In the former, undulating terrain was echoed in uneven base-lines, while the chaos and carnage of battle was sometimes represented by the complete absence of base-lines.

Formal Egyptian art was extremely formal. It was a rigidly applied style of representing the people and times it set out to portray. That it became, or can now be perceived as art of the very highest quality, is testament to the quality of craftsmanship Egyptian artists employed to transform mere reportage into a dynamic, vivid and captivating record of a remarkable people.

▶ AT PLAY

A BANQUET SCENE FROM THE TOMB OF NEBAMUN, IN THEBES. THE
ARTIST BROKE WITH FORMAL STYLE TO SHOW (LOWER REGISTER, MIDDLE
RIGHT), TWO LADIES IN CONVERSATION. ONE OFFERS THE OTHER A
LOTUS BLOSSOM TO SMELL. THE CONES ON THEIR HEADS
CONTAINED SCENTED OINTMENT AND WOULD MELT DURING THE
EVENING.

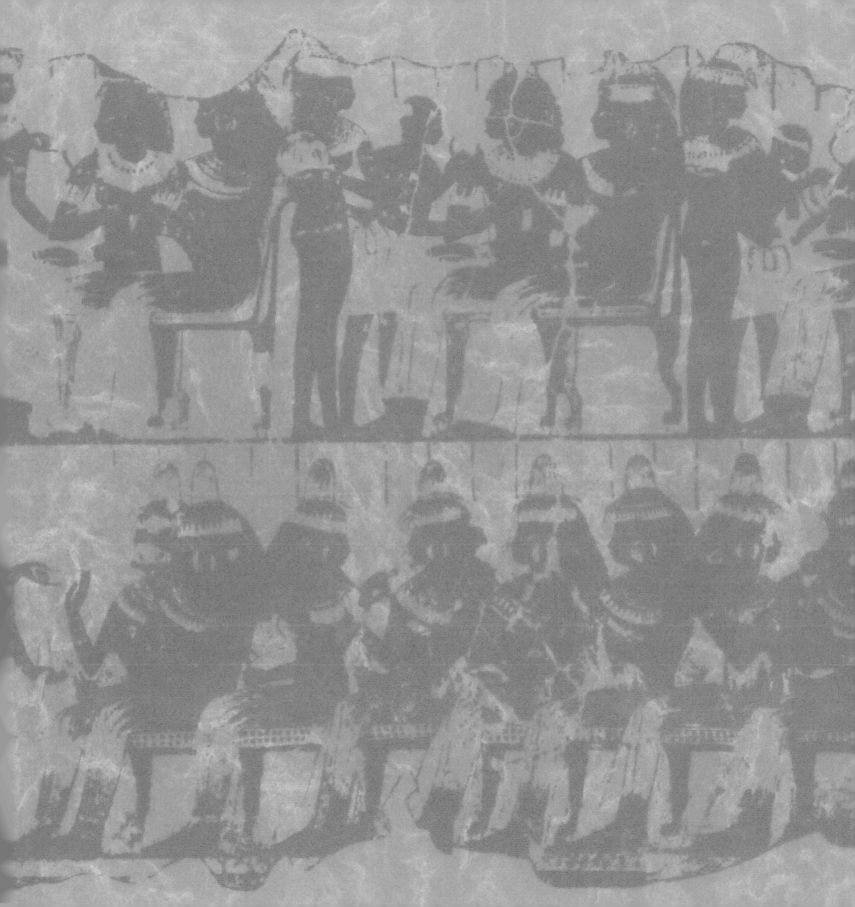

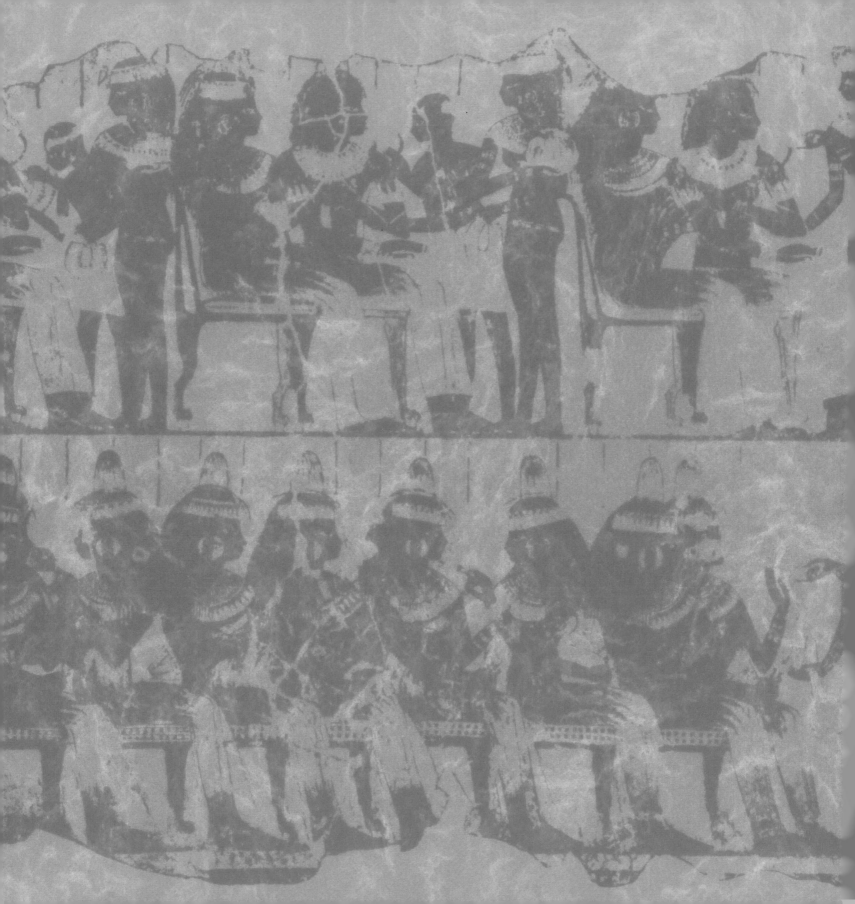

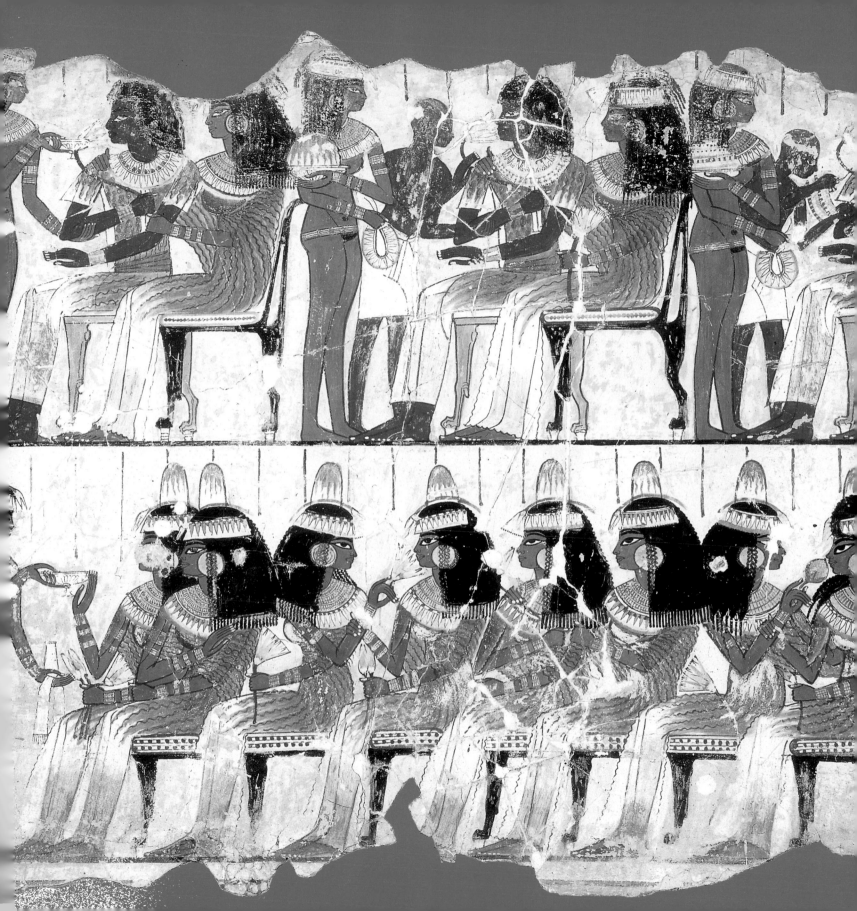

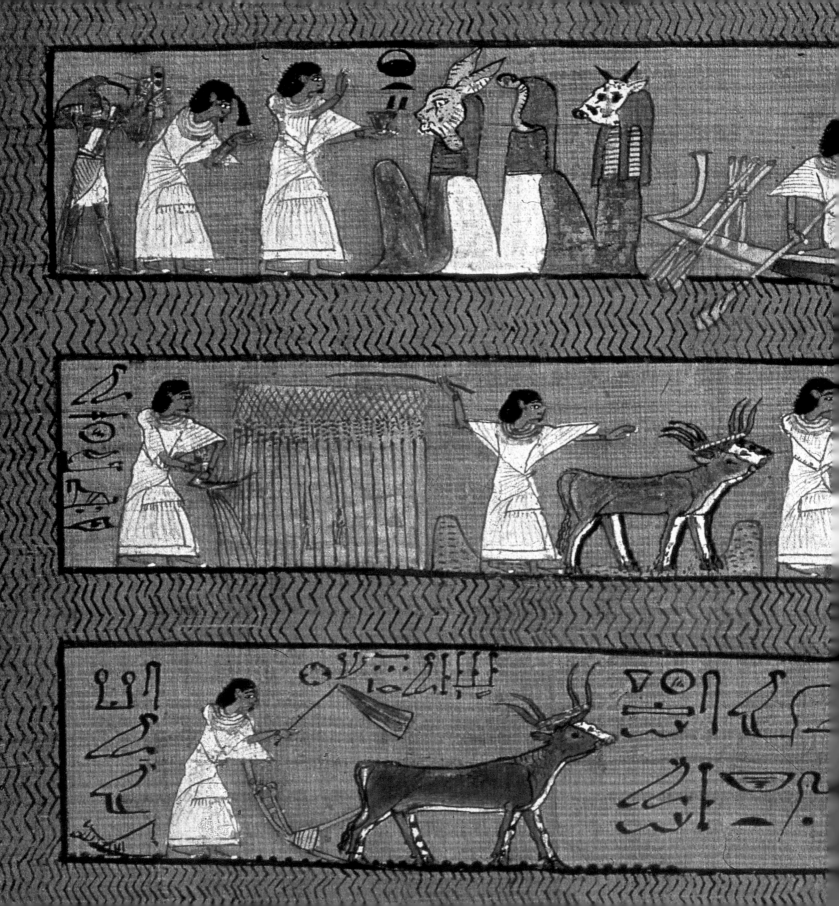

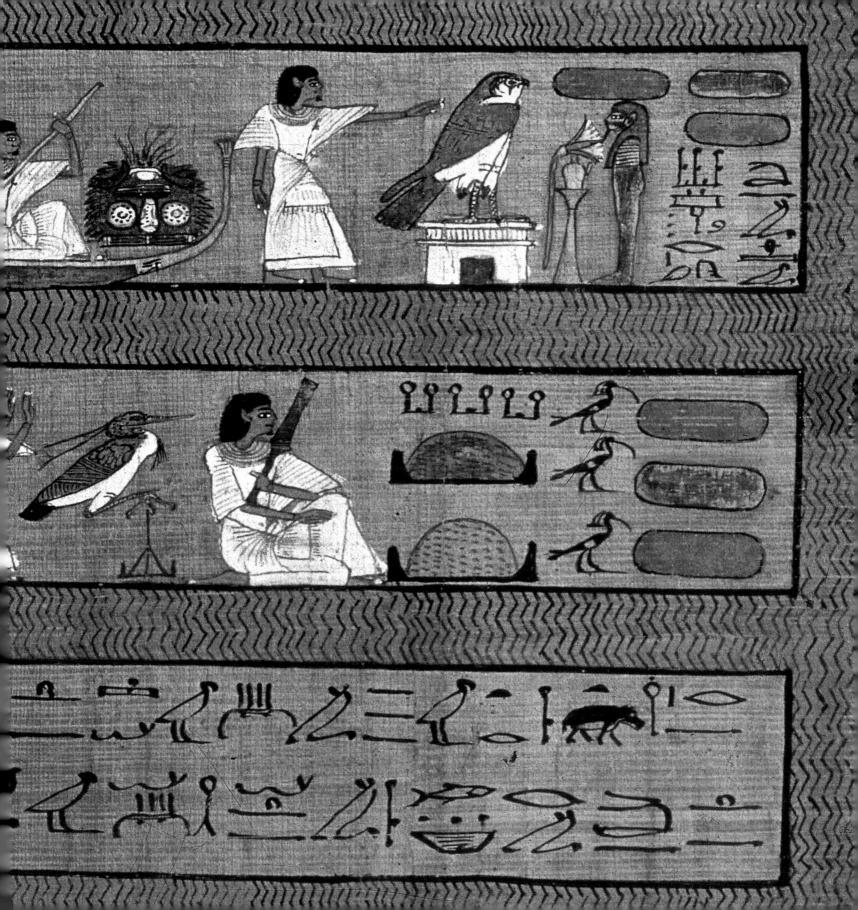

CHAPTER 3
TECHNIQUES OF THE MASTER CRAFTSMEN

C onsidering how intrinsically important the decorative arts were to Egyptian palaces, temples, and tombs, it's remarkable to learn that there appears to have been no cult of the artist in ancient times.

Indeed, there does not even seem to be a hieroglyph for the word "painter." The names of a few individuals are known only because they were owners of certain tombs, not because they were ever given any credit for designing or executing the work they spent a lifetime creating, often in exquisite detail, on walls and other surfaces they believed would never again be viewed by human eyes.

For the most part, the artists and craftsworkers who toiled uncredited through the 3,000 years of Pharaonic rule were members of hand-picked teams who worked under a supervisor scribe who would have sketched and specified precisely what images would go where after consulting whoever commissioned the work. There was little, if any, room for individuality or self-expression. What they brought to their task, however, was an incredibly high degree of technical excellence and superb draftsmanship, and their work is no less brilliant for having been executed to precise order.

From the buildings which now stand revealed in the principal sites, it can be seen that painted carved relief was the most common form of decoration. Where these survive more or less intact it is clear that the carvings and inscriptions were painted only when the stonemasons had completed a task which was itself based on outline "sketches" drawn on the raw monoliths by scribes who were charged with the entire project.

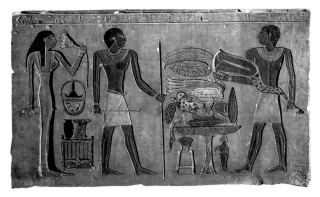

◄ FOOD FOR THE DEAD
SUSTENANCE WAS STILL REQUIRED IN THE AFTERLIFE. IN THIS PAINTED STONE RELIEF, WHICH DATES FROM THE 12TH DYNASTY (C.1980 B.C.), KHETY'S SON AND WIFE PRESENT OFFERINGS OF FOOD TO HIS PARENTS.

► PREPARING THE WAY
SCRIBES DEPICTED AT WORK IN A DETAIL FROM THE TOMB WHICH THEY WERE CREATING—THAT OF THE COURT OFFICIAL, REKHMIRE.

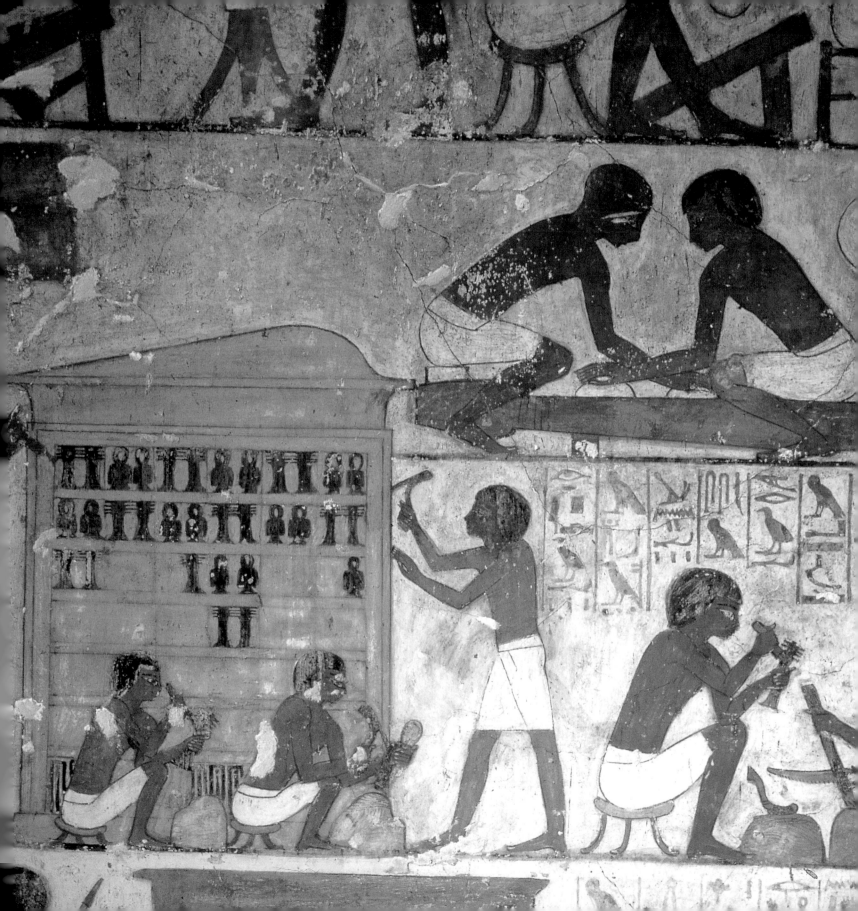

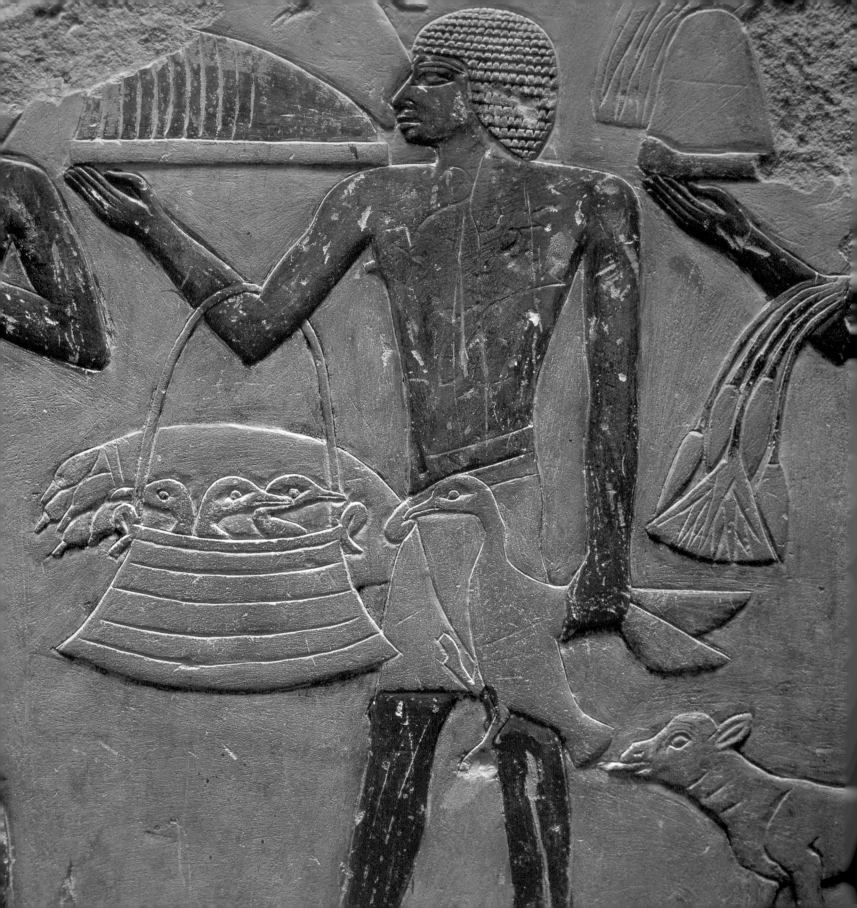

However, carved reliefs were not always an option open to those who commissioned such work, especially in tombs carved from living rock. Cost was one inevitable factor, for it must have been very expensive to retain a team of designers, masons, and painters for very long periods. Time was another, for a tomb may not have been fully completed when its owner died. In such cases the plan to decorate a tomb completely with relief might have to be abandoned and the remaining walls completed with drawings and paintings, which gave the artists a greater degree of artistic freedom.

The key factor, however, was the suitability of the stone itself. In the case of temples and palaces, only the finest products of Egypt's granite quarries at Aswan would have been employed. Hauled into place and manually polished to a superb finish, these stones would pose no problem to the outline scribe, the sculptors, or the teams of painters who would then enhance the carvings, often with a wealth of added detail. This would not always be true of the rock in hillsides excavated to create tombs, and the preponderance of wall paintings in some can easily be attributed to relatively poor or flawed stone which was simply unsuitable for extensive carving.

In such cases—as with paintings that survive in humbler settings where the raw material was mostly unbaked mud-brick walls covered with plaster—it is relatively easy to see just how Egypt's scribes and painters set about their work and the raw materials they used to create their masterpieces.

Neither the huge carved scenes that fill temple walls, nor the smaller-scale decorations of tombs, could have been simply sketched out ad hoc by outline scribes, no matter how gifted they may have been. Extensive plans must have been drawn up and finalized in meetings with clients or their agents, and while no such preliminary drafts have yet been unearthed, the distinct absence of mere repetition in different portrayals of the most popular subjects and stories militates against the theory that Egypt's master craftsmen merely used standardized stylebooks or pattern books. Even if there was some conventional way of depicting deities and kings and a prescribed formula for emphasizing their dominance, there is too much that is unique in most surviving examples for artistic license not to have been allowed or encouraged.

◄ BIRDS FOR A PRINCESS

A PORTER CARRIES A BASKET OF FLEDGLINGS, PURSUED BY A CALF, IN THIS DETAIL OF A RELIEF PAINTING FROM THE TOMB OF THE 6TH DYNASTY PRINCESS, IDUT.

► BLIND HARPIST

CAPTURED BY THE ARTIST IN MID-STROKE, A BLIND HARPIST PLAYS IN THIS EXQUISITE RELIEF FROM THE 19TH DYNASTY.

Given that outline scribes were men who had risen through the ranks (either by merit or nepotism) to direct operations, they would have undergone the same intensive training as those beneath them and so would have at their disposal a comprehensive knowledge of the large repertoire of scenes they would most commonly be asked to incorporate in different settings. The fact that none of their initial plans have survived is undoubtedly due to the simple fact that such "blueprints" would have been drawn on wooden boards or papyrus parchments and then discarded once a job was completed.

Once a design had been approved and the stone or wall section had been prepared satisfactorily (poor stone or brick walls overlaid with a chaff-reinforced plaster, then a thin coat of finer gypsum plaster and a final thin layer of colored wash), it would be the scribe's task to reproduce it on a large scale—a task which was made relatively simple by drawing a grid on the wall or stones to be decorated and then outlining the figures according to an established protocol. The lines for these grids were produced, it's believed, by soaking thin cords in red paint, stretching them until taut and snapping them against the surface to be painted or carved.

The proportions for these grids appear to have been derived from those of a "standard" human figure and, for most of the Pharaonic period, resulted in a grid of 18 squares high—from the sole of the foot to the point where hairline meets forehead. The overall width could vary, being limited only by the length of area to be worked. There were occasional variations in this basic scheme, most notably in the late 18th Dynasty when 20 squares were used to determine height, and in the 26th Dynasty when 21 squares became the norm. Whatever the number, the grids were used to establish the height of the principal character, with other subordinate figures and activities being arranged in smaller scale within the overall boundaries of the grid, to complete the composition and allow the painters to begin.

▶ THE SYSTEM

THIS DETAIL OF A 5TH DYNASTY RELIEF DEPICTING AKHETHOTEP AND PTAHHOTEP IS A CLEAR ILLUSTRATION OF THE CLEAR SUBDIVISION OF ELEMENTS WHICH CHARACTERIZES FORMAL EGYPTIAN PAINTING.

◀ THE GRID

A WOODEN DRAWING BOARD WAS USED TO CREATE THIS GRID-MARKED REPRESENTATION OF THUTMOSIS III, THE 18TH DYNASTY RULER. RED INK WAS USED TO MARK THE GRID—THEN OF EIGHTEEN SQUARES IN HEIGHT —WITHIN WHICH THE FIGURE OF THE KING WAS CAREFULLY DRAWN. AS THUTMOSIS WAS SEATED, ONLY FOURTEEN SQUARES WERE USED.

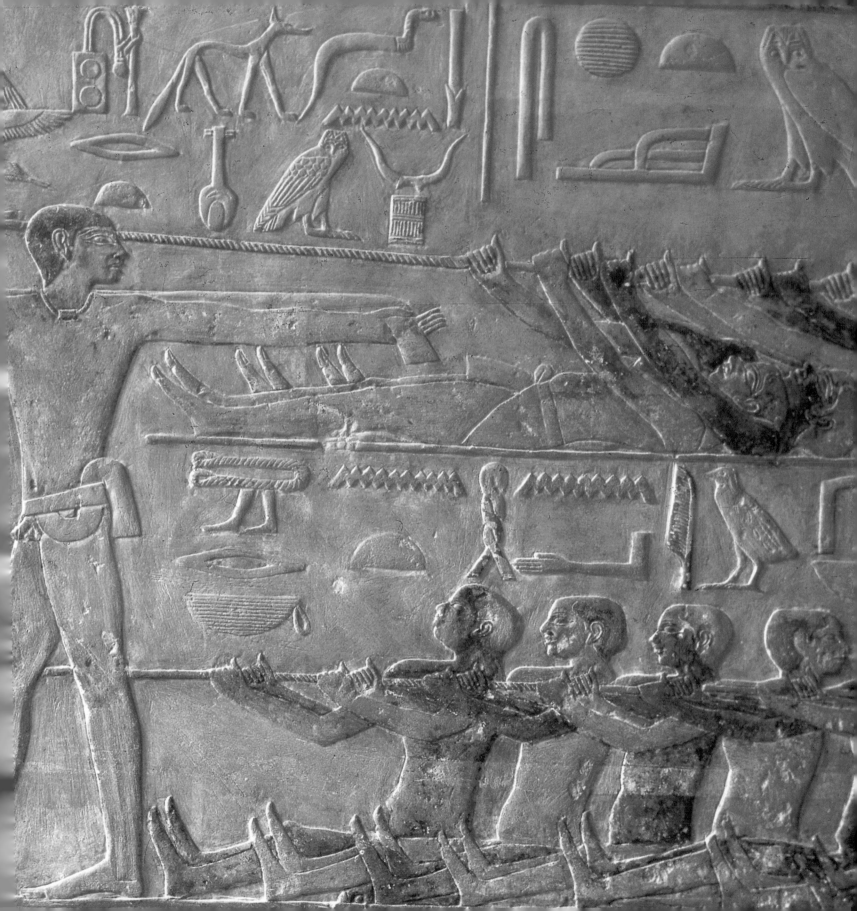

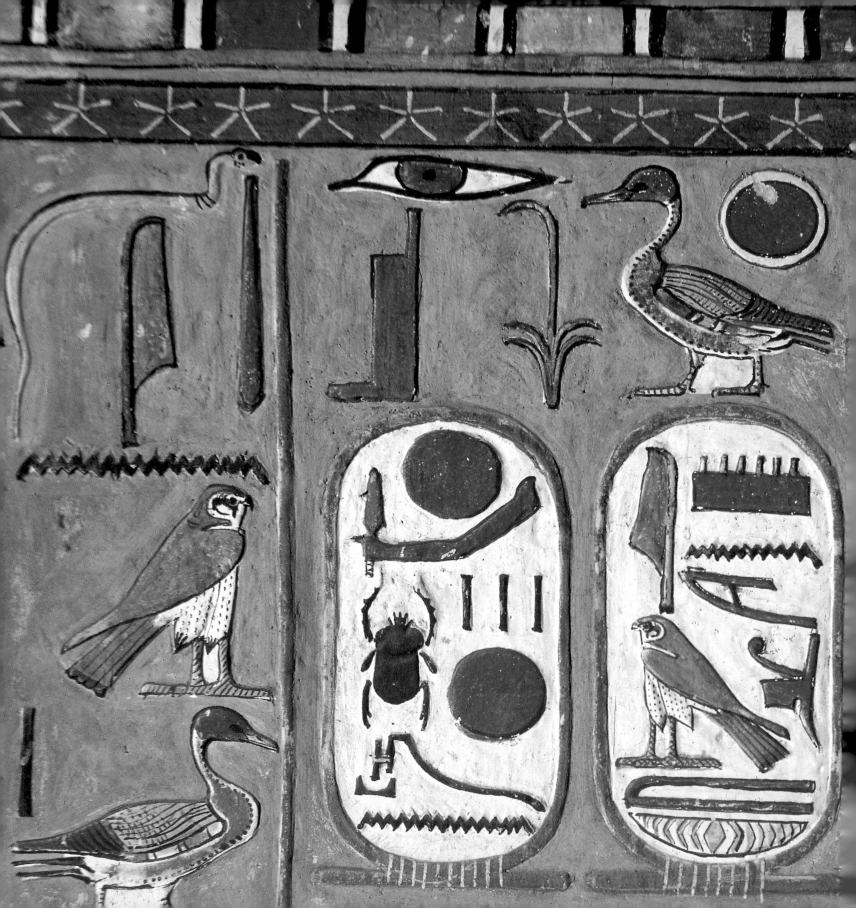

When one views the still-brilliant colors and superb draftsmanship of much Egyptian art, it is hard to accept that they were applied with the crude and cumbersome brushes that have been found.

One particularly fine example of a painter's "kit" found in an 18th Dynasty tomb at Thebes by archaeologist Norman de Garis Davies consisted of pieces of palm-rib, fibrous wood, and twigs, the tips of which were crushed to create crude brushes. These were undoubtedly used for less elaborate work, as were bundles of palm-rib which, as one source has it, would have produced something akin to a modern shaving brush!

Finer, more detailed sections of relief and wall paintings were probably created by using a variation of the brushes employed by scribes to write on papyrus parchments. These "pens" are often found in collections of scribes' equipment, the palettes of which have slots to hold them in place. Made from a fine rush (Juncus maritimus), which still grows abundantly in Egypt, the tips of these reeds are easily trimmed to make a very fine brush with which one can make either thick or very thin lines.

From pictures depicting scribes at work we know that they held these brushes in much the same way as a painter does, with the hand away from the surface of the work. So it is more than likely that such implements were also used in painting, even if no hard evidence exists to support the theory. And while scribes' palettes contained two small carved reservoirs to hold their black and red paints or inks, the artists used clay pots for their paints.

◄ THE KING'S SEAL

WITH COLORS STILL VIBRANT, A WALL PAINTING DEPICTING THE KING'S SEAL OF HOREMHEB, FROM THE 18TH DYNASTY TOMB AT THEBES.

▲ TOMB OF NEFERTARI

THE RIOT OF COLORS AND FINE DRAFTSMANSHIP WHICH GREET THE VISITORS TO THESE TWO ROOMS IN THE TOMB OF QUEEN NEFERTARI, IN THE VALLEY OF THE QUEENS AT THEBES, IS STILL AWE INSPIRING.

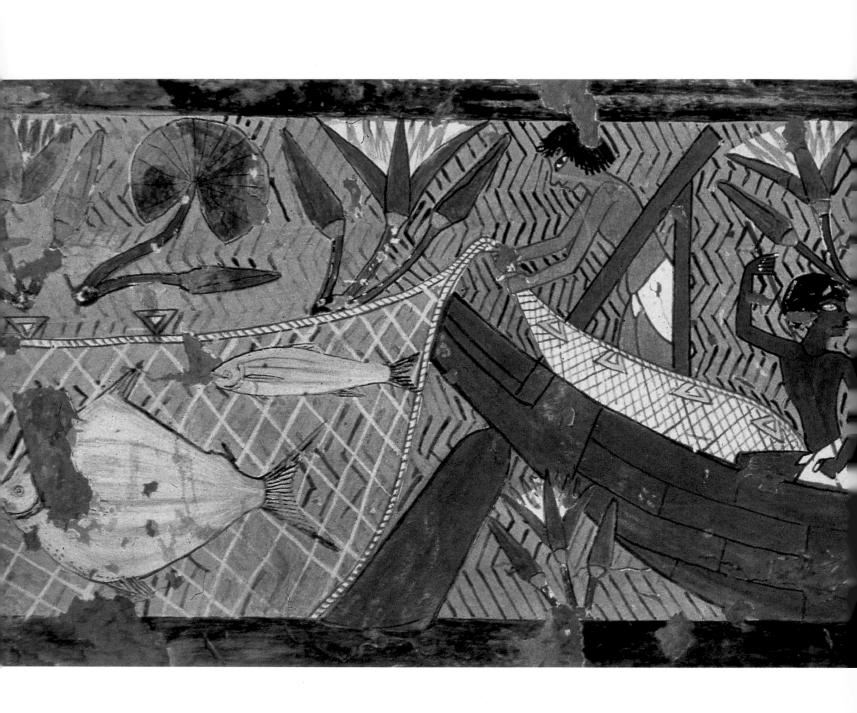

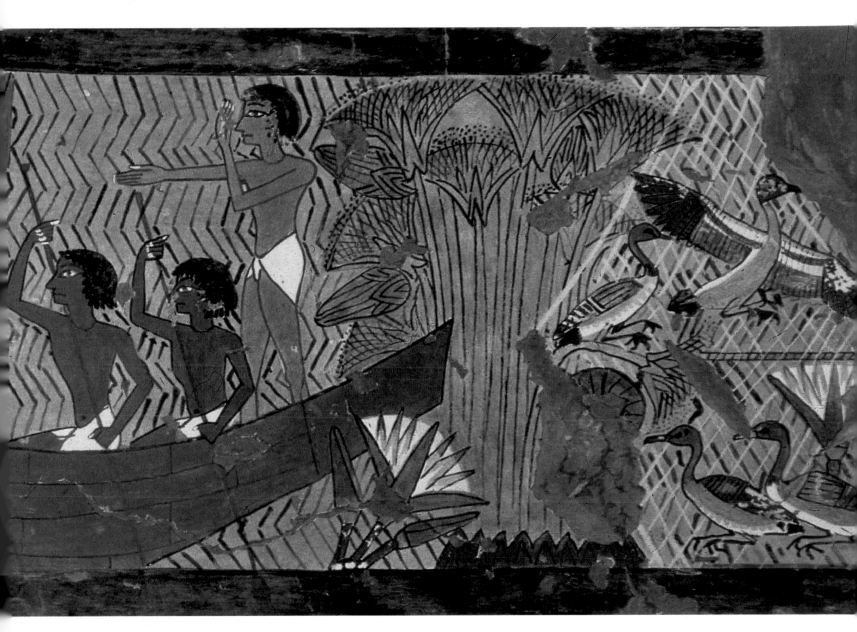

▲ FISHING

A GROUP OF MEN FISHING IN A PAPYRUS THICKET, THEIR NET AND CATCH
VISIBLE ON THE LEFT—A DETAIL FROM ONE OF THE SUPERB FRESCOS
FOUND IN THE TOMB OF IPUY, A SCULPTOR, IN DEIR EL-MEDINA.

The pigments used to create these paints were generally made from natural minerals, the intense colors of which were not liable to fade or change. Modern technology has enabled us to determine precisely how those paints were manufactured: raw material was ground into a fine powder before a binding agent—probably a vegetable gum—was used to form it into small cakes.

Another agent would have been used to apply the paint, and scientific opinion is split between three options—egg, a gelatinous substance called size, or gum. Egypt's climate argues against the use of egg, however. But there is no doubt that the substances used to create the primary colors were:

BLACK — Carbon. Readily available in many forms including lamp black created by the flames of oil lamps, burned bones, or soot scraped from cooking pots.

WHITE — Calcium sulphate (gypsum) or chalk

BLUE — a compound of silica, calcium, and copper, most usually in the form of ground malachite, quartz, natron, and calcium carbonate.

YELLOW — usually yellow ocher, but a sulphide of arsenic called orpiment became common from the end of the 18th Dynasty (see Chronology), probably imported from Persia.

GREEN — mostly copper ore, but green pigment could also be made from using powdered malachite or a green frit similar to the one used to make blue.

RED — oxides of iron and red ocher.

Egyptian painters were skilled at blending these primary colors to create subtle shades. Applying them to walls was achieved by a technique known as tempera or gouache—colors mixed with a binding medium that enabled it to be applied with water. They did not, as was originally thought, use the fresco method of painting directly onto wet plaster, nor work in oils.

Finally, the painters would protect and enhance their work with natural resin varnishes. Although this was more common with painted wooden artifacts, sections of wall paintings were varnished this way. There is evidence to suggest that beeswax was also used to the same end. Inevitably, those wall areas that were varnished have suffered from yellowing, which has altered the tones of the paint beneath—not the effect those master craftsmen intended, but proof that they could err!

► **MONKEY BUSINESS**
THESE CHARMING STUDIES OF BABOONS, WITH INSCRIPTIONS, ACCOMPANIED THE YOUNG TUTANKHAMEN INTO THE AFTERLIFE.

While it is obvious that scaffolding and walkways must have been built so that artists could decorate carved reliefs on the top of columns and paint high walls in temples, palaces, and the grander homes, it remains a source of wonder that they were able to execute such detailed and subtle work in the depths of tombs where no natural light could have reached. Even in outer chambers into which some sunlight did occasionally filter, they would have needed artificial aids to counter poor visibility.

As ever, the ancient Egyptians appear to have been equal to the task. Although most oil lamps gave off smoky flames, the ceilings of tombs are free of soot deposits. From contemporary records we know that strict control was maintained over the issue and return of wicks specifically designed for the purpose—probably prepared tapers that had been impregnated with fat or oil which, while efficient, did not give off unwanted smoke.

Nevertheless, lighting conditions in the tombs must have been very bad. The superb results achieved can be explained by two facts—paints were undoubtedly mixed in daylight to guarantee the right blend of tones, and the Egyptian painter was simply accustomed to and trained for such terrible conditions. Also, he was working to order.

All of which is feasible, but it doesn't begin to explain how these men produced work which is rarely less than accomplished and often can only be described as beautiful, sensitive, and astonishingly delicate. The outline scribes and their teams were no mere technicians, but true artists in every sense of the word.

▶ SENNEFER'S TOMB

DESPITE APPALLING LIGHTING CONDITIONS, THE SCRIBES AND PAINTERS WHO DECORATED THIS WALL IN THE TOMB OF SENNEFER, MAYOR OF THEBES AND GARDEN SUPERVISOR FOR KING AMENOPHIS II, MANAGED TO CREATE A MINOR MASTERPIECE OF DESIGN AND COLOR.

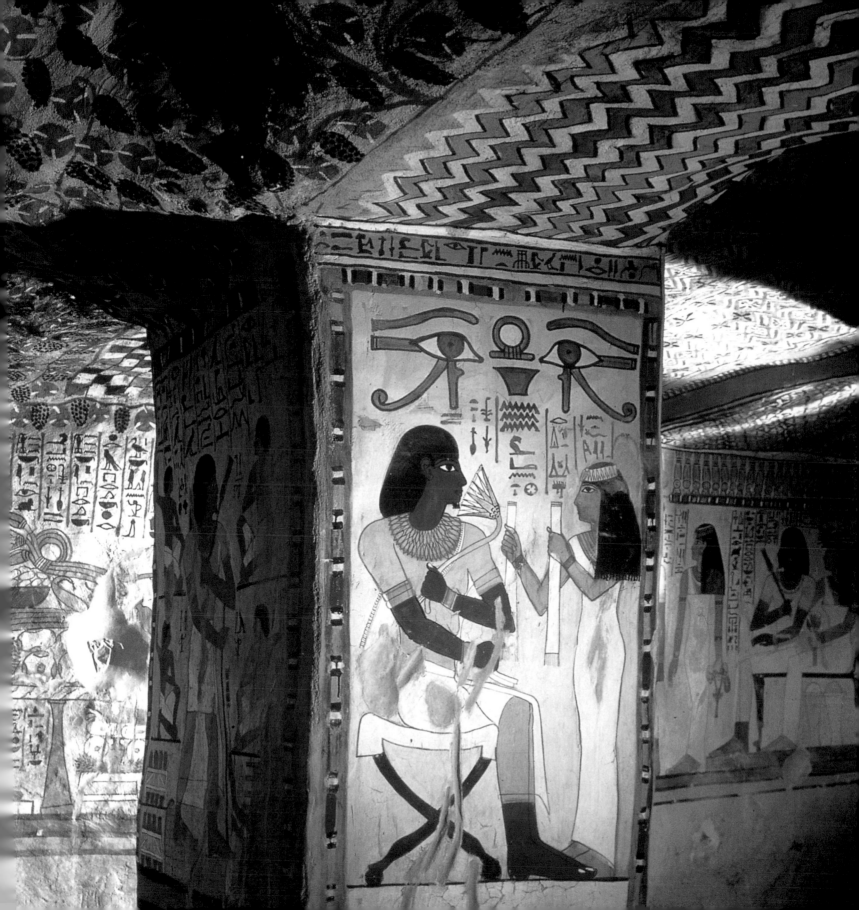

A ll decorative Egyptian wall art was, as we have already seen, based on and around initial line drawings designed and put in place by outline scribes who would also be responsible for adding new, amended, and final outlines once the masons or painters had finished their part of the work.

Given that those initial drawings were destined to be painted over or carved away with chisels, you could be forgiven for assuming that they would be little more than sketches that acted merely as the starting point for an elaborate form of painting by numbers, given the rigid conformity that seems to have been applied to the task of creating murals.

However, the evidence of our own eyes belies any charge of purely mechanical "filling in" on the part of Egypt's master-painters, and the mass of line drawings that have survived in various sites provide ample proof that the outline scribes devoted as much time, energy, and skill to their initial drawings as any artist determined to create a composition that would last forever.

Besides giving us a marvelous insight into the methods employed in creating wall art, those preliminary sketches also prove that a great amount of detail was included from the very beginning, often revealing draftsmanship of great subtlety and line drawings of an elegance and wit which can—and do—act as an inspiration and role model for modern artists who want to perfect the art of drawing. In the case of initial outlines, it is possible that the scribe was merely making sure that—in the eventuality of a tomb not being completed—his work could stand in place of what was meant to be painted or carved. Professional pride alone would have dictated care and attention to detail.

► **OSIRIS**

SIMPLICITY AND GRACE OF LINE COMBINE TO CREATE THIS ELEGANT DEPICTION OF THE GOD OSIRIS, WHICH CAN BE FOUND IN THE TOMB OF SENNEDIEM, A 14TH CENTURY BC OFFICIAL OF THE CITY OF DEATH COMPLEX, WHICH LIES IN THE NECROPOLIS OF DEIR EL-MEDINA, THEBES.

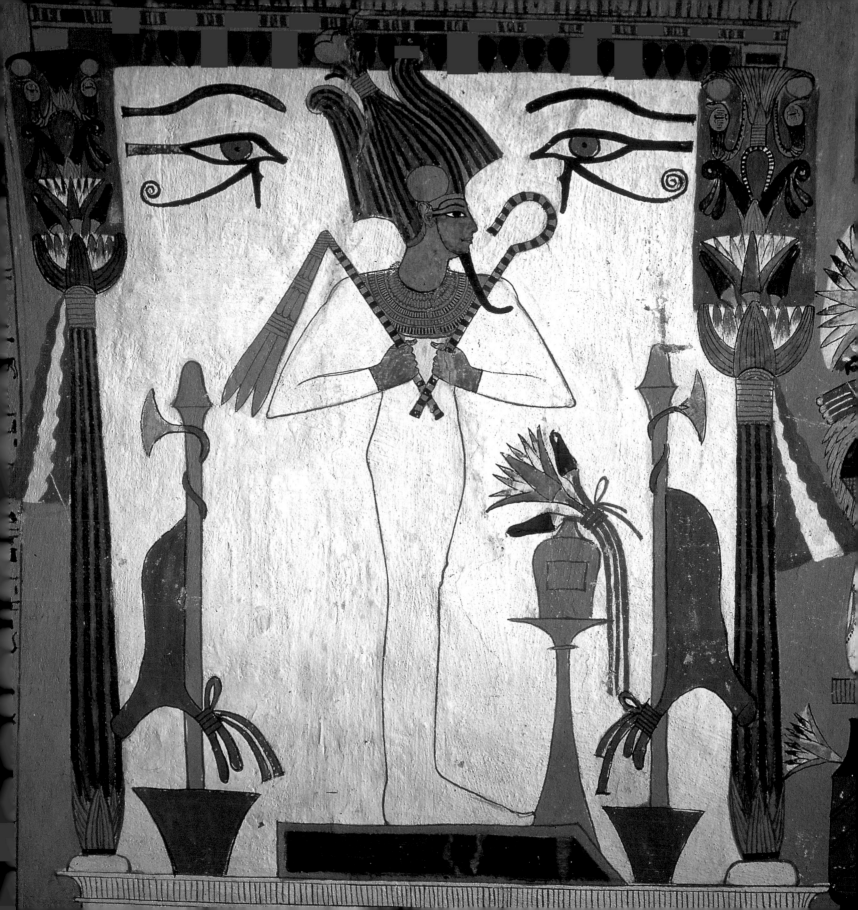

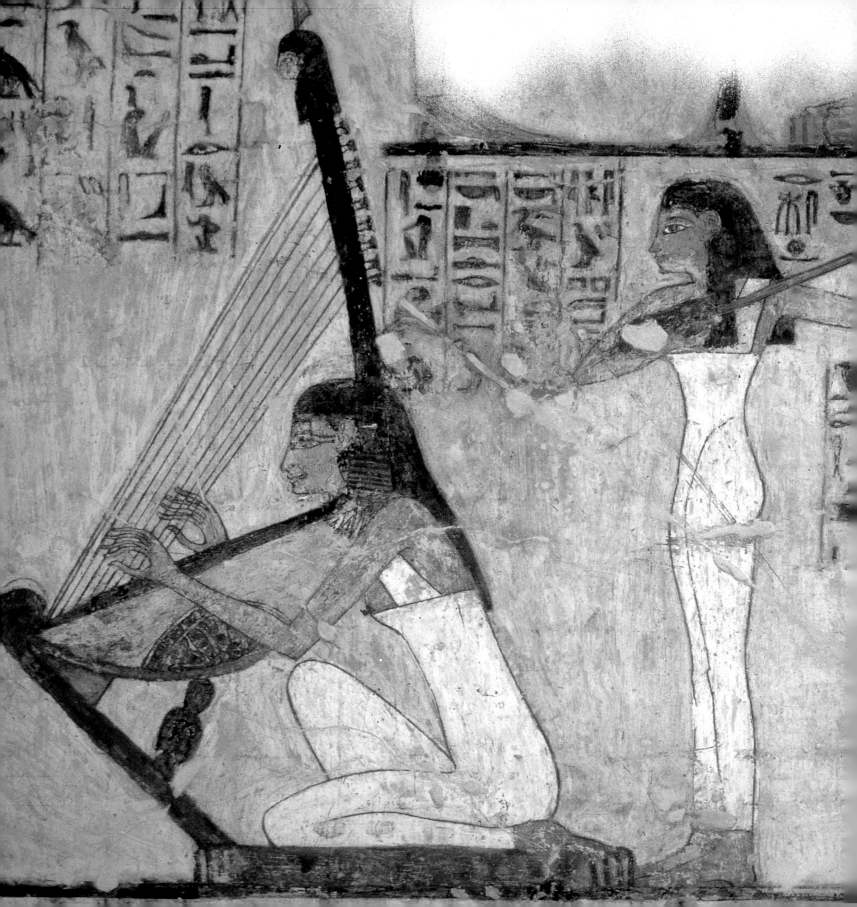

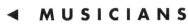

◄ MUSICIANS

A STUDY OF FEMALE MUSICIANS IN A DETAIL FROM A WALL PAINTING
IN THE TOMB OF COURT OFFICIAL REKHMIRE (C.15TH CENTURY B.C.).

Not all surviving Egyptian line drawings are the result of unfinished projects, however. Some are examples of uncolored brushwork which was clearly intended to remain in that state—maybe because the death of a tomb owner meant that time was suddenly pressing, or that funds had simply run out and that was all he or she could afford to have done. The single greatest store of such artistic riches is to be found in the mass of tombs located in The Valley of the Kings near Thebes, a large number of which were obviously unfinished (in decorative terms) when their owners took up residence. Surprisingly—for it was surely of paramount importance that a ruler's "home" for eternity be in as perfect a state as possible—many royal tombs are often in this uncompleted condition.

Where walls have been left unfinished, with reliefs not fully carved or outline drawings only partially painted, the full process of Egyptian wall decoration can be viewed in detail; the techniques and various stages revealed provide art historians and tourists with invaluable technical insight.

This is especially true, for example, in the tomb of Amenophis II, an 18th Dynasty pharaoh. There, most of the main decoration remains in line form alone, with color having been added only on block borders, the ceiling, and a few other areas. The drawings of scenes which grace the pillars of the sarcophagus chamber are examples of superb draftsmanship, and while it is generally assumed that these—and the many other drawings made in the tomb—were intended to be eventually painted over or chiseled away, it is possible that they were judged to be of high enough quality to survive intact and therefore left unadorned.

► OFFERING LIBATION

A PRACTICE SKETCH IN RED PAINT BY AN UNKNOWN ARTIST, DEPICTING
AN UNIDENTIFIED KING OFFERING A LIBATION, HAS SURVIVED ON THIS
OSTRACON (LIMESTONE FLAKE).

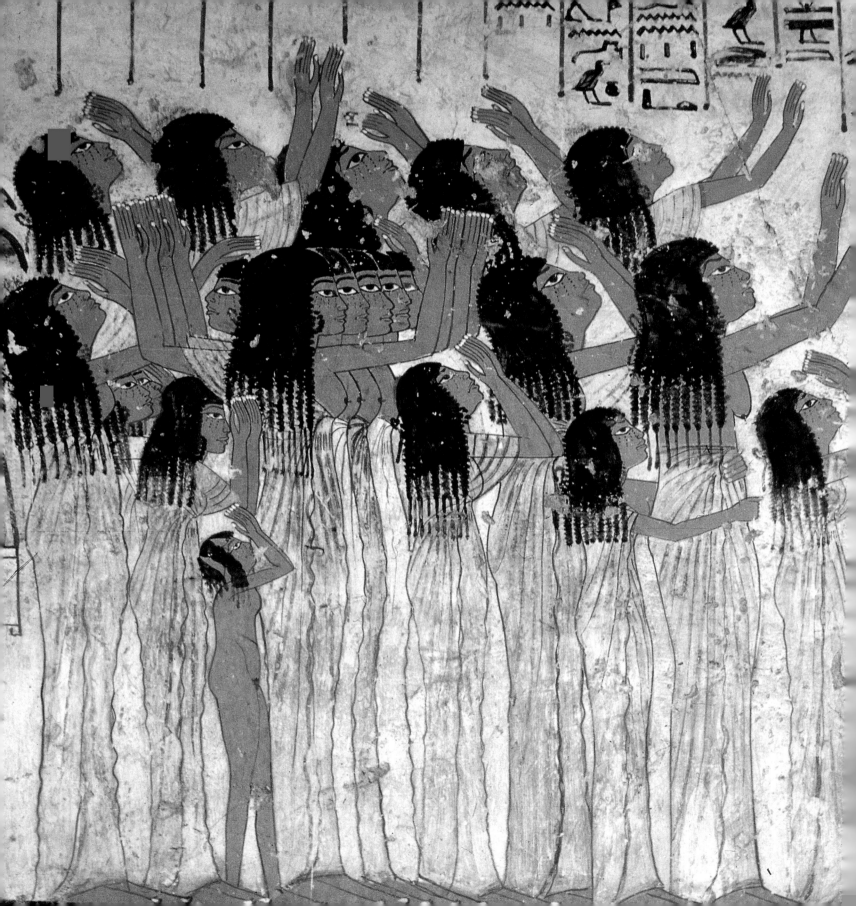

One of the other tombs located in the necropolis of Thebes—that of Ramose, who was vizier to both Amenophis III and Akhenaten in the 18th Dynasty— is of particular importance to art historians.

Not only does it contain exceptional carved low relief work and painted scenes in the "accepted" styles of both the 18th Dynasty and the distinctly different one adopted during the reign of the "heretic" king, Akhenaten, but it also boasts a quantity of preliminary drawings and unfinished reliefs.

Ramose's tomb provides a valuable and rare glimpse into the ways in which its creators had to tackle a substantial (if short-lived) change in formal artistic fashion, a rare event in a civilization which was largely content to stick with what it "knew" for many generations and allowed only very minor and subtle shifts in style when they did make a change. The dramatic transition from the more "traditional" representation of figures to the more naturalistic "new wave" of Akhenaten is most marked in two uncompleted scenes which flank the entrance to an undecorated inner chamber.

One, which depicts Ramose presenting flowers to Amenophis IV (Akhenaten's name before he changed it to reflect his devotion to Aten as the only one true god), was drawn on prepared limestone and, although masons had begun work on carving the distinctly high 18th-Dynasty-styled figures, the scribe's red grid can still be clearly seen.

◄ MOURNING WOMEN

GREAT ATTENTION TO DETAIL WAS MADE TO CREATE INDIVIDUALS IN THIS DEPICTION OF WOMEN MOURNING THE DEATH OF RAMOSE, ONE OF AMENOPHIS IV'S GENERALS, WHOSE TOMB LIES IN TELL EL-AMARNA.

► THE CORTEGE

(OVERLEAF) DETAIL FROM A WALL PAINTING IN THE TOMB OF SENNEFER, MAYOR OF THEBES UNDER AMENOPHIS II: A BOAT CARRIES SENNEFER'S EMBALMED BODY TO ABYDOS

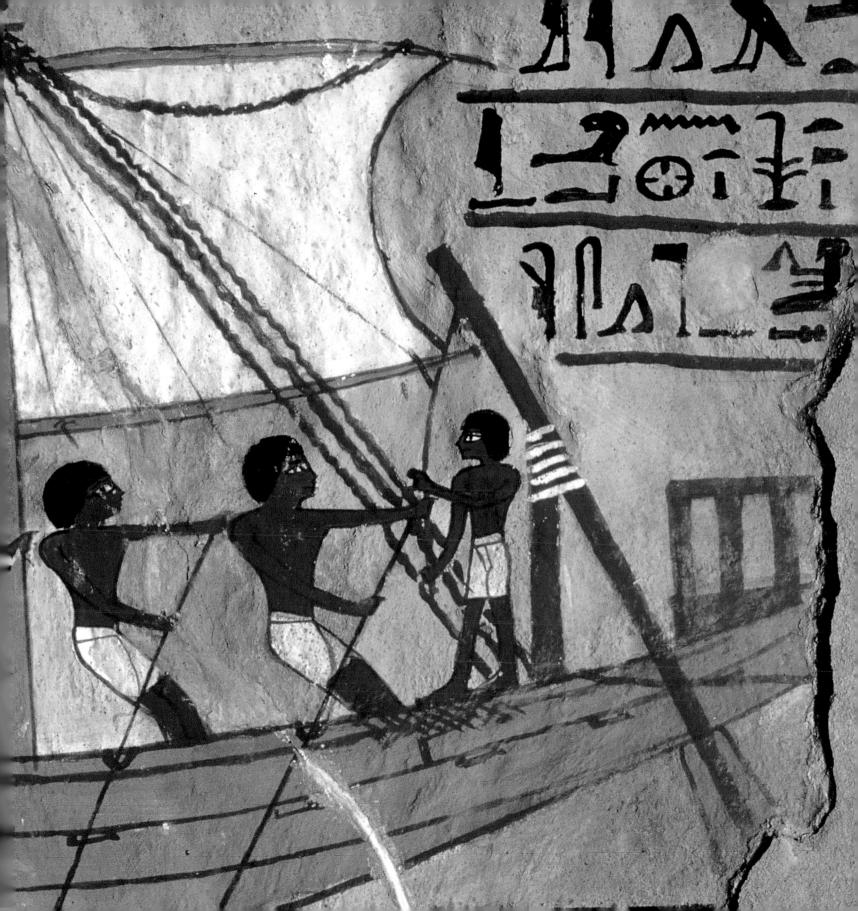

Opposite this, and in complete contrast, the other scene has been drafted in the "new" style favored by Akhenaten and Queen Nerfertiti in their subsequently demolished court in Akhetaten. While many other examples of this style found in Thebes are tentative, even clumsy, the one in Ramose's tomb is confident, masterful, and drawn with complete assurance. Of special note is a group of Syrian, Nubian, and Libyan emissaries, their heads drawn to emphasize their individuality and racial distinctiveness as they prostrate themselves before the king.

Although the two scenes are many years apart in style and execution, and it is likely that they would not have both been created by the same man, the later work is every bit as accomplished as the earlier. One theory is that the scribe responsible for the later drawing may have simply followed designs made by others who'd been taught in what is now called the Amarna style. This would not necessarily have been a come-down for him, for learning by copying played a central role in a scribe's training. So there would be no disgrace attached to working to a brief prepared by another. Remember, these men painted to order, even if some of their work was markedly individual within such confines.

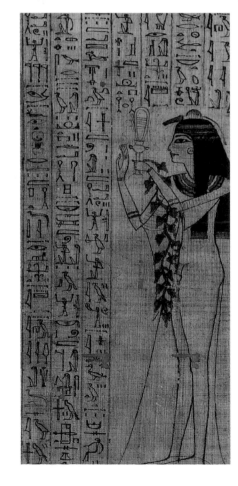

▶ WORKING BY TORCHLIGHT

IN THIS DETAIL FROM THE FINAL VIGNETTE IN THE BOOK OF THE DEAD OF ANI, THE SCRIBE, A HIPPOPOTAMUS GODDESS (POSSIBLY A FORM OF THE GODDESS HATHOR) IS SHOWN HOLDING A LIGHTED TAPER OF TWISTED LINEN. IT IS BELIEVED THAT THIS WAS THE KIND OF TORCH PAINTERS USED TO ILLUMINATE THE DARKEST RECESSES OF TOMBS.

◀ ANHAI'S ADORATION

ECONOMY OF LINE WAS USED TO GREAT EFFECT BY THE ARTIST WHO CREATED THE BOOK OF THE DEAD FOR ANHAI, THE 20TH DYNASTY SINGER-PRIESTESS OF AMEN. IN THIS DETAIL, ANHAI IS SHOWN IN A CLASSIC POSE OF ADORATION. IN ONE HAND SHE HOLDS A SISTRUM—A MUSICAL RATTLE TRADITIONALLY USED IN THE WORSHIP OF ISIS AND A SYMBOL OF HER OFFICE—AND A LENGTH OF VINE.

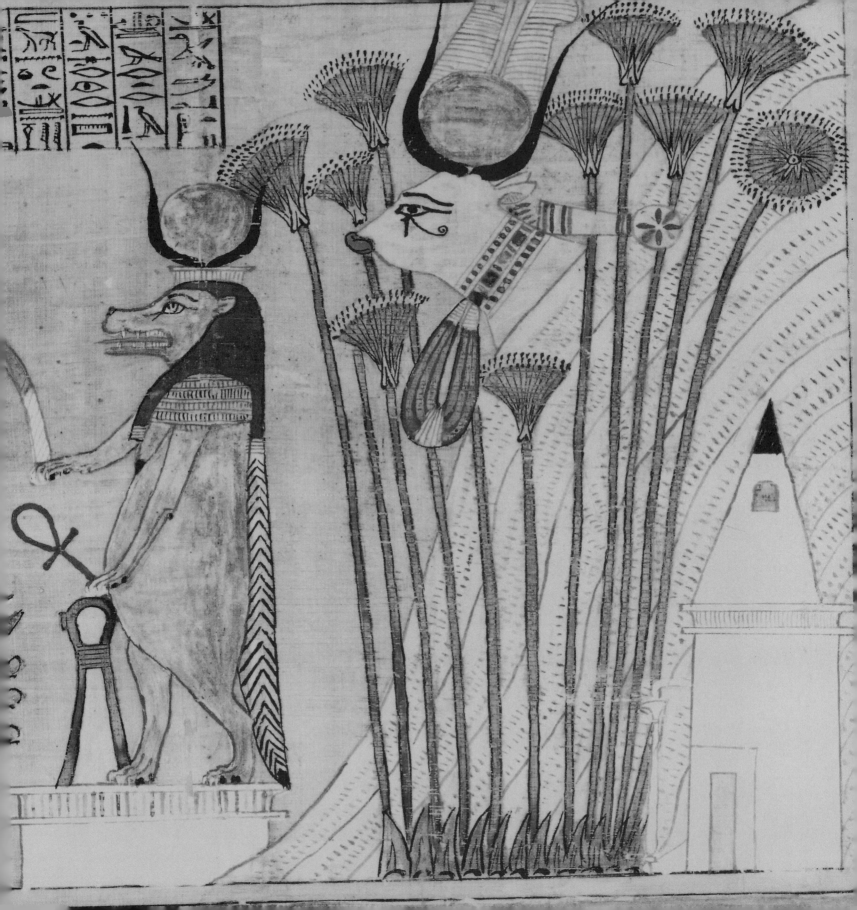

There is ample evidence that great emphasis was laid on the skill of accurate copying—especially of "standard" pictorial themes which would have been in greatest demand—and student scribes may have had to make sketches of important or popular reliefs in major public buildings, or even within the confines of temples.

It was certainly not unknown for scribes to "borrow" from one site when they were beginning to work on another, and a number of preliminary sketches exist to prove it. One such—on a large *ostracon* (limestone flake) in the British Museum—is of Ramesses IX gesturing to two men carrying fans. Although not an exact copy, it owes a great deal (including its hieroglyphic inscription) to two very similar scenes which have survived elsewhere. One can be found in the mortuary temple, at Medinet Habu, of Ramesses III, who had reigned 40 years earlier than Ramesses IX. The other is in Ramesses III's temple at Karnak. However, it is believed that the British Museum scene was probably a student's test drawing and not a full working drawing—that would have more likely been committed to papyrus or wooden board, the usual mediums used for presentations to clients.

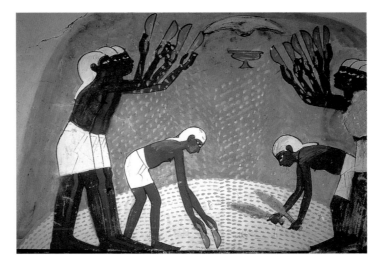

▲ ▶ COPYING AND BORROWING

THE PRACTICE OF "BORROWING" WAYS OF DEPICTING OFT-REPEATED PICTORIAL THEMES IS AMPLY ILLUSTRATED IN THESE PAINTINGS OF FIELD WORKERS FROM DIFFERENT TOMBS OF THE SAME PERIOD. THE DETAIL (ABOVE) OF MEN THRESHING CORN COMES FROM THE 18TH DYNASTY TOMB—AT SHEIK ABDEL-KURNA—OF NAKHT, AN ASTRONOMER AND COURT OFFICIAL TO THUTMOSIS IV. THE ALMOST IDENTICAL THRESHERS DEPICTED IN THE CENTER OF THE PICTURE OPPOSITE ARE TO BE FOUND IN THE TOMB OF MENNA, A SCRIBE WHO WORKED FOR THE SAME KING. IT IS, OF COURSE, POSSIBLE THAT THE SAME ARTISTS WORKED ON BOTH TOMBS, BUT IT IS JUST AS LIKELY THAT THEY RELIED ON THE SAME TEACHING TEXTS TO CREATE THEIR "STANDARD" FIGURES.

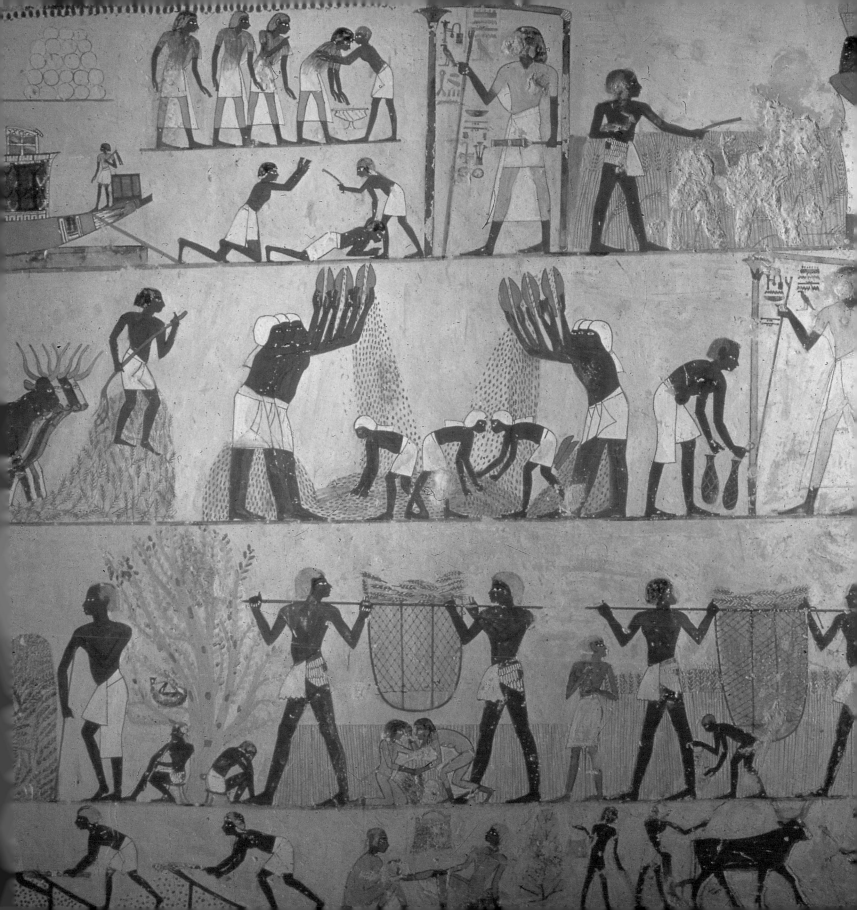

CHAPT

PAINTING THE EVERY

It is on papyrus or wood that the most outstanding Egyptian drawings and paintings can be found, with many revealing a grace, fluidity, and an incredible eye for detail and form that is unrivaled in any comparable ancient civilization.

In general, the figures of pharaohs, queens, gods, and goddesses are portrayed in formal style, but the true genius of Egyptian scribes lay in the ways in which they "captured" animals, lesser mortals and aspects of daily life, work, and recreation.

Sadly, we have been left very few major artistic representations of the everyday life and activities of the ordinary men and women who lived under the pharaohs. The art of temples, royal tombs, and palaces inevitably reflected and concentrated on the life, times, and religious beliefs of those for whom such sites were built. Official Egyptian art was strictly formalized, so lesser mortals were invariably depicted in much smaller scale—court officials, visiting ambassadors, servants, slaves, or captives all received the same short shrift in the name of political correctness.

▶ PREPARING FOOD

THE PROCESS OF PREPARING FOOD (FOR A BANQUET?) IS CHARMINGLY CAPTURED IN THIS DETAIL FROM THE 18TH DYNASTY TOMB OF OUNSOU, AT THEBES. IN THE UPPER REGISTER, THE BUTCHERS CUT AND DRESS A SLAUGHTERED COW. IN THE CENTER, FOWL AND RABBITS ARE PRESENTED, WHILE TWO SERVANTS BEAR PLATTERS OF FISH IN THE LOWER REGISTER.

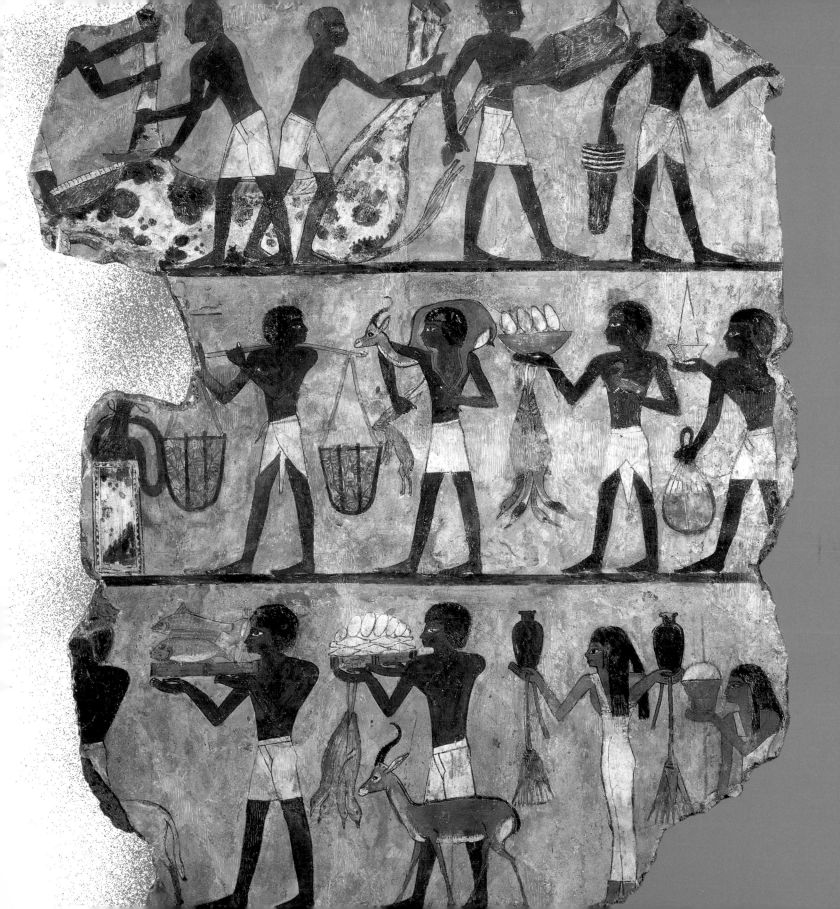

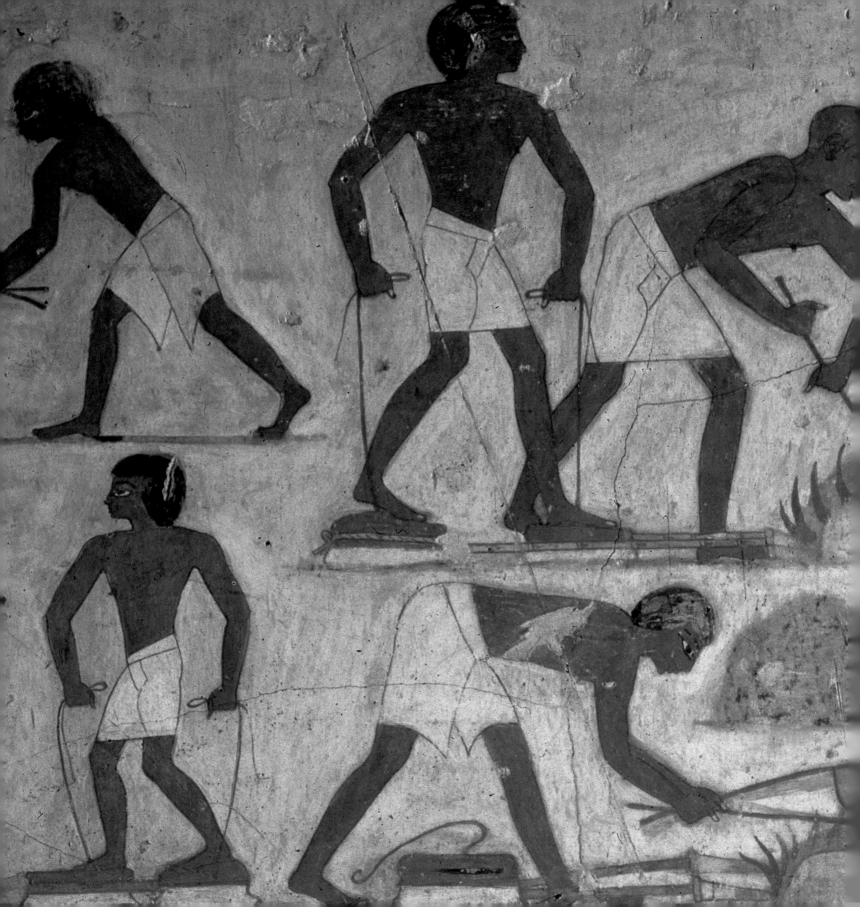

◄ A BRICKYARD

BRICK-MAKING IS DEPICTED IN THIS DETAIL OF A WALL PAINTING WHICH SHOWS REKHMIRE, OWNER OF THE TOMB IN WHICH IT CAN BE FOUND, INSPECTING A BRICKYARD AS PART OF HIS DUTIES FOR THUTMOSIS III OR AMENOPHIS II, BOTH OF WHOM HE SERVED.

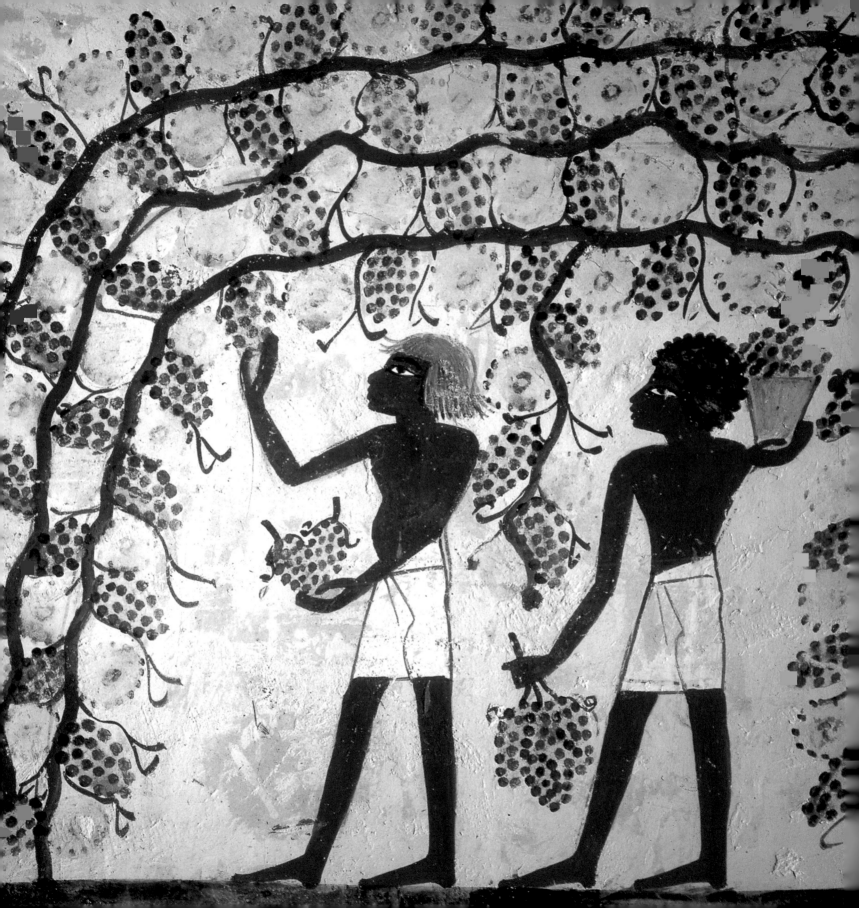

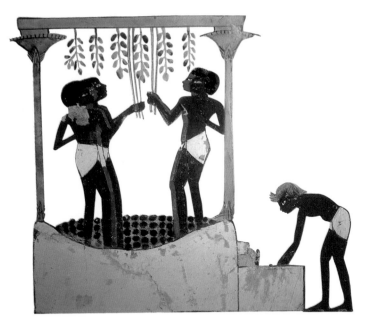

Where peasants do appear in formal art, they tend—in a very real sense—to be little more than mere footnotes. They may be portrayed hunting, shooting, fishing, sowing, reaping, or herding livestock, but that is invariably to emphasize the images of peace and prosperity the ruler wanted to serve as his memorial for future generations and history. Thus, livestock and their handlers appear as little more than chattels for a census-taker to count, with crops massed as evidence that—under this pharaoh at least—the living was easy and the times were good.

The problem for those who have searched for a more accurate and less formal depiction of the everyday is, as we noted earlier, the simple fact that the homes of the lower Egyptian orders were not, in the whole, substantial stone buildings. They were humble mud-brick dwellings which, if they survived for any great length of time, were either eventually demolished to make way for something better or abandoned for the same reason. As is so often the case with ancient Egypt, the most we have to go on are only fragments, many of which have been found in the village built at Thebes (by King Amenophis I, it is believed) to house those artisans who were responsible for creating the great necropolis city in the Valley of the Kings.

It is in the Valley of the Nobles and the Valley of the Artisans that the greatest number of depictions of the everyday have been found. The tombs there contain a wealth of detailed references to the more mundane and routine aspects of their owners' existence and to the scenery and wildlife with which they would have been surrounded.

◀▲ GRAPE HARVEST

THE VITAL TASK OF HARVESTING GRAPES, AS PORTRAYED (LEFT) IN
A PAINTING FROM THE TOMB OF NAHKT, A PRIEST-SCRIBE UNDER
THUTMOSIS IV. THE NEXT STAGE—THE AGE-OLD METHOD OF CRUSHING
GRAPES UNDERFOOT, AND THE COLLECTION OF THEIR JUICE—IS
DEPICTED (ABOVE) IN AN ADJOINING SCENE.

It is also true that purely decorative murals were features of many private rooms of royal palaces and those of court nobility. Surviving examples of these reveal that the natural world featured largely in such work, with an almost complete absence of human figures in compositions which would—often in astonishingly accurate detail and exquisite colors—concentrate on plants and flowers, fruit and other foodstuffs, fish, fowl, and domestic animals, all of them in startling contrast to the highly formalized geometric patterns which formed the centerpieces and focal points of walls and floors.

Where a room or courtyard boasted a fish pond, for instance, the surrounding floor would be decorated with representations of plants, fish, and banks of reeds. Ceilings, on the other hand, would be painted to represent the sky, so birds were naturally the only wildlife depicted in those areas.

The more affluent Egyptians were not above the odd touch of titillation in their domestic décor, so motifs featuring naked or scantily-attired young girls are not uncommon. In these, the subjects are generally featured carrying bunches of flowers or playing a musical instrument, and it was popular practice to set these alluring figures against a background of marsh plants. Given that the occupants of tombs went to them convinced that they were about to enter an eternity in which they would need all of the little luxuries they'd enjoyed in this life, dancing girls can also be found in many a subsidiary tomb scene, undoubtedly for companionship or entertainment.

▲ ▶ MUSICIANS

THE CREATION AND PERFORMANCE OF MUSIC BECAME AN ADVANCED—
AND HIGHLY HONORED—ART FORM IN ANCIENT EGYPT, AND NO SOCIAL
EVENT WOULD HAVE BEEN COMPLETE WITHOUT MUSICAL
ENTERTAINMENT OF SOME KIND. A TWIN OBOE, A LUTE, AND A HARP
ARE AMONG THE INSTRUMENTS PLAYED BY THE 15TH CENTURY BC
FEMALE MUSICIANS DEPICTED ABOVE.

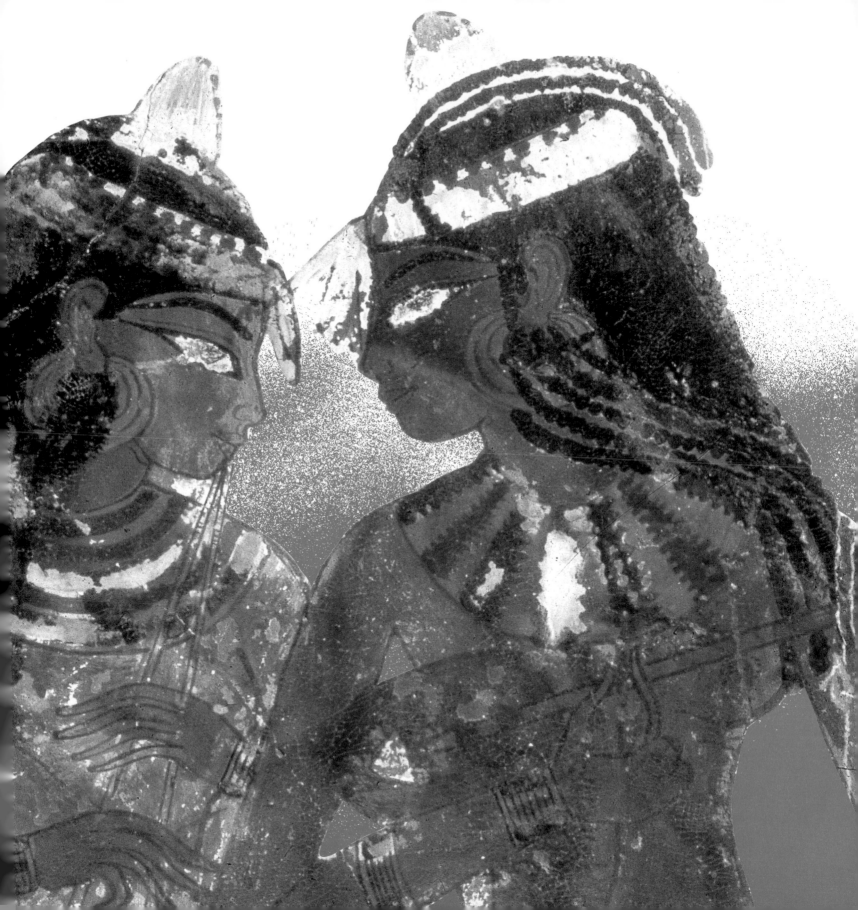

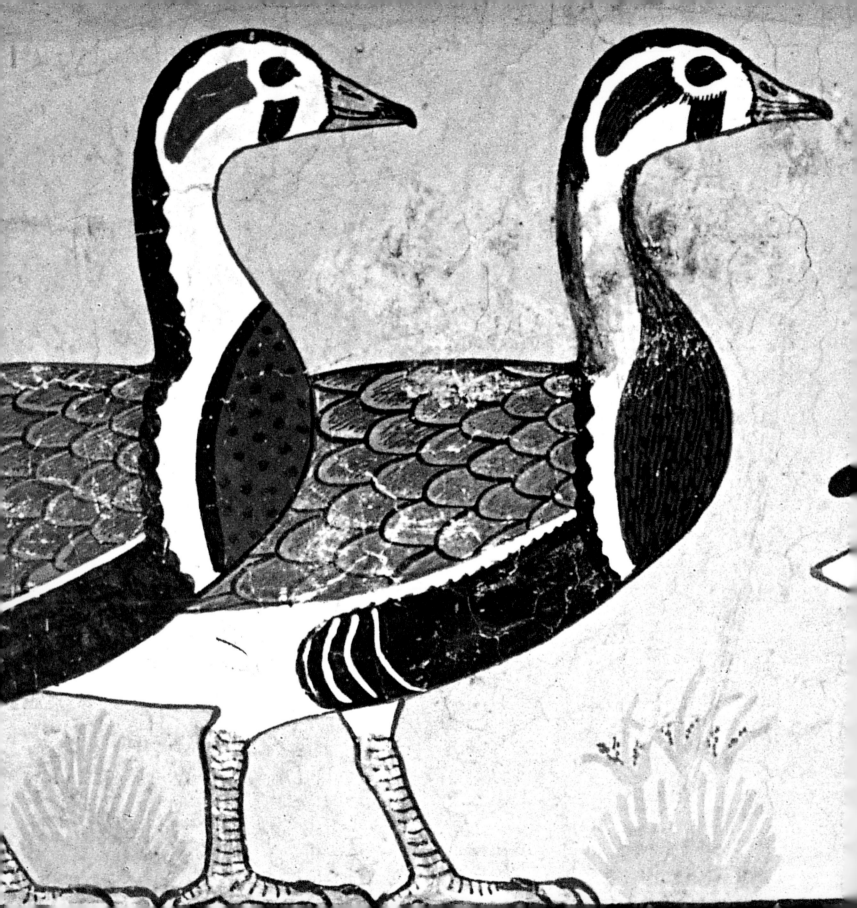

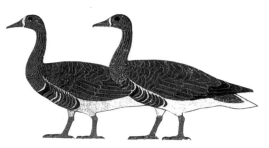

A number of the more popular domestic motifs were also found in tombs, especially those elements which had a particular symbolism—the fish signified fertility, for instance, while the lotus represented rebirth. Both appear with regularity in homes and tombs, as do trapped or flying birds, marsh plants, and dancing calves, many of which display an elegant sense of movement. As in all other forms of decoration which are found in both homes and tombs, the latter tend to appear more formal, as befits the solemnity of their location.

Predators such as panthers, hounds, and lions were also a universally popular domestic decoration through the ages, usually portrayed in the action of pulling down their prey. Indeed, the oldest recorded example of this theme—a steatite (soapstone) disk of the 1st Dynasty—would have been almost 2,000 years old when the necropolis of Thebes was being constructed and similar paintings were being included in the decor of new tombs!

There is also little doubt that, from the very earliest times, successive generations of Egyptian artists took a special—and fully justified—pride in their skill in painting animals and birds. Even when the general quality of work in some of the minor tombs can best be described as shoddy or slapdash, it is invariably true that the sections featuring such images tend to be much superior in their execution and finish.

Strangely, the detail, care, and skill which was lavished on wildlife images actually seems to have peaked at a very early historical stage. One of the earliest and finest examples of Egyptian wall painting —a scene of geese found in the 4th Dynasty (around 2600 B.C.) combined tomb of Nefermaat, the son of King Snefru, and his wife, Itet—depicts the birds in superbly accurate detail, with each sub-species clearly identifiable. The masterful use of stippling and shading combine to give depth and astonishing texture to what are actually flat areas of color. Known as "The Meidum Geese," this masterpiece now has a rightful prominence in the Cairo Museum; New York's Metropolitan Museum of Art has a very good facsimile painting of it on permanent display.

◄ ▲ MEIDUM GEESE

GESSO (A PREPARED PLASTER) AND PAINT WERE USED BY THE GENIUS WHO CREATED "THE MEIDUM GEESE" (LEFT AND ABOVE) FOR THE SHARED TOMB OF NEFERMAAT AND ITET. THE RANGE OF COLORS, THE SUBTLETY OF LINE, AND THE CLOSE ATTENTION TO DETAIL MAKE THEM WORKS OF SHEER BRILLIANCE, ALL THE MORE SO AS THEY WERE PAINTED C.2600 B.C. THE ILLUSTRATIONS USED HERE ARE FACSIMILES, BY ARCHAEOLOGICAL ARTIST NINA DAVIES, OF THE ORIGINALS HOUSED IN THE CAIRO MUSEUM.

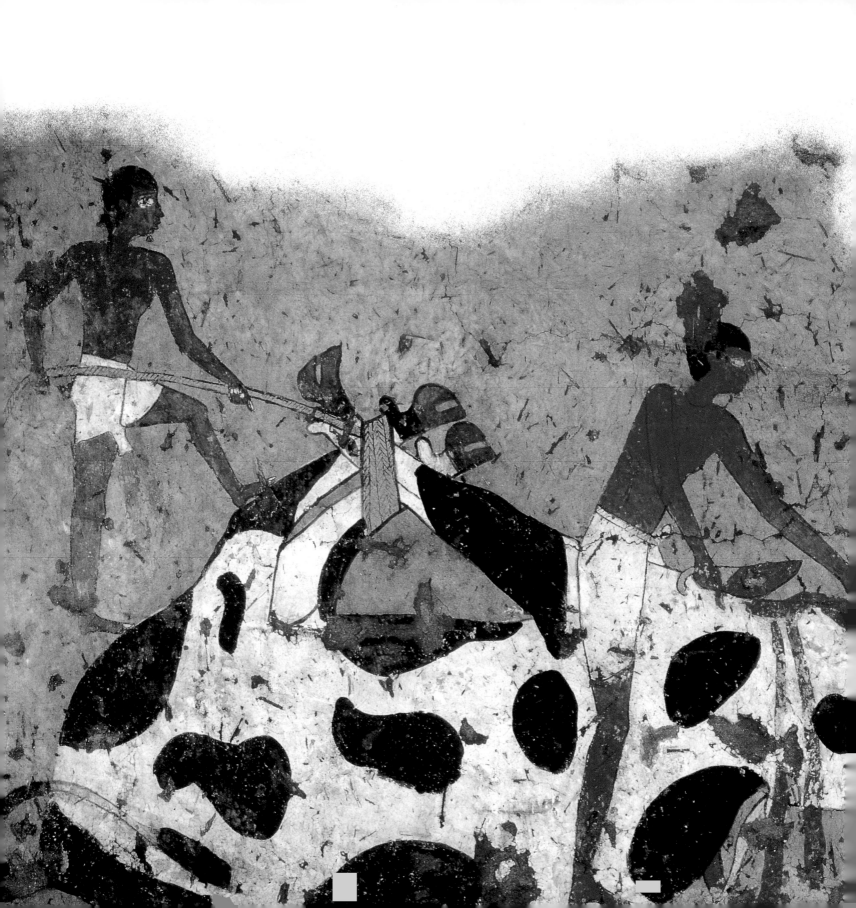

▶ BES

A STATUE OF BES, THE HOUSEHOLD GOD WHOSE IMAGE WAS ONE OF
THE MOST COMMON SUBJECTS OF DOMESTIC ART.

The tradition of placing everyday objects in tombs—furniture, tools and toys included—also preserved much domestic artwork that would otherwise have been lost to us. From the furniture decoration we know that one of the most common subjects of domestic art was Bes, the household god.

A dwarfish creature with the features, mane, ears, and tail of a lion, Bes is also found on the surviving walls of workers' houses in El-Amarna (near the site of Akhenaten's destroyed city of Akhetaten) and Deir el-Medina (by the funerary complex at Thebes), as well as the palace of Amenophis III at Malkata.

We know that the houses of officials and nobles at El-Amarna were decorated with murals and that it was common practice to feature a frieze of lotus flowers along the top of walls, adding pendant swags of birds (usually ducks) at intervals beneath, as well as floral garlands. Surviving examples of such work suggest that the original colors were brilliant and rich, even if such decorations were surely not intended to last forever.

But the single most beautiful example of ancient Egyptian domestic or secular art—and the most precious—comes from the so-called "Green Room" of the Northern Palace at El-Amarna, its name inspired on the room's predominant colorings. Part of its surviving decor is in the British Museum but, because of its time-ravaged state, the mural's full glory is best captured in the facsimile painting made on-site by archaeological artist Nina de Garis Davies before the termite-riddled plaster was lifted from the wall which it adorned.

The decoration revealed a unity of design in its overall conception which is quite unlike the formal linear style which graced earlier temples and tombs, most especially in its presentation of a unified and continuous panorama of early life in the marshes of the Nile. The walls were filled with a background of massed reeds, their flowers painted in such a way as to represent their swaying in a breeze. Birds appear about to take flight, as if the artist had disturbed them, fly in the sunlight or settle to rest on crushed-down papyrus stems, through which the heads of lotus flowers push their way for a glimpse of the sun. Unfortunately, no humans are included in this superbly executed scene.

◀ SACRIFICE TO THE GODS

OBEISANCE, SUPPLICATION, AND SACRIFICE WERE VITAL IF EGYPT'S MANY DEITIES WERE
TO BE HONORED, PLACATED, OR THEIR AID INVOKED. A BULL IS SACRIFICED IN THIS
PAINTING FROM THE TOMB OF ITY, A HIGH COURT OFFICIAL WHO LIVED DURING THE
MIDDLE KINGDOM (LATE 22ND-EARLY 21ST CENTURY B.C.).

It is the murals in tombs of court officials, scribes and master craftsmen which give us the best opportunity to view the Egyptians at work and play. The most outstanding paintings of the Middle Kingdom (c 2050-1786 B.C.) can be found in Beni Hasan, in the necropolis of nobles of the Oryx Nome.

In the rock-hewn tomb of Khnumhotep, a *nomarch* (district governor) of the mid-12th Dynasty, one of the murals shows men picking figs in his gardens while baboons lurk in a tree, stealing their own share. This picture is especially unusual in that the painter attempted to show the effort involved by including both shoulders of the fruit pickers and packers.

In fact, the tomb painters of Beni Hasan were apparently not content to stick with the convention which dictated that lesser figures were shown only in profile, for there are other murals of unusual themes (groups of wrestlers, for example) in which they have tried to capture the distortion of muscles and limbs which occur in strenuous activity. They don't, it must be said, always succeed that well, but they are commendable attempts at a more naturalistic treatment of "real" people and events.

▶ WRESTLING
THE PAINTERS OF BENI HASAN BROKE WITH FORMAL STYLE WHEN CAPTURING THE EXERTIONS, TWISTS, AND TURNS OF THE WRESTLERS.

◀ GYMNASTICS
THE SAME FREEDOM OF EXPRESSION WAS USED TO DEPICT THESE GYMNASTS IN TRAINING.

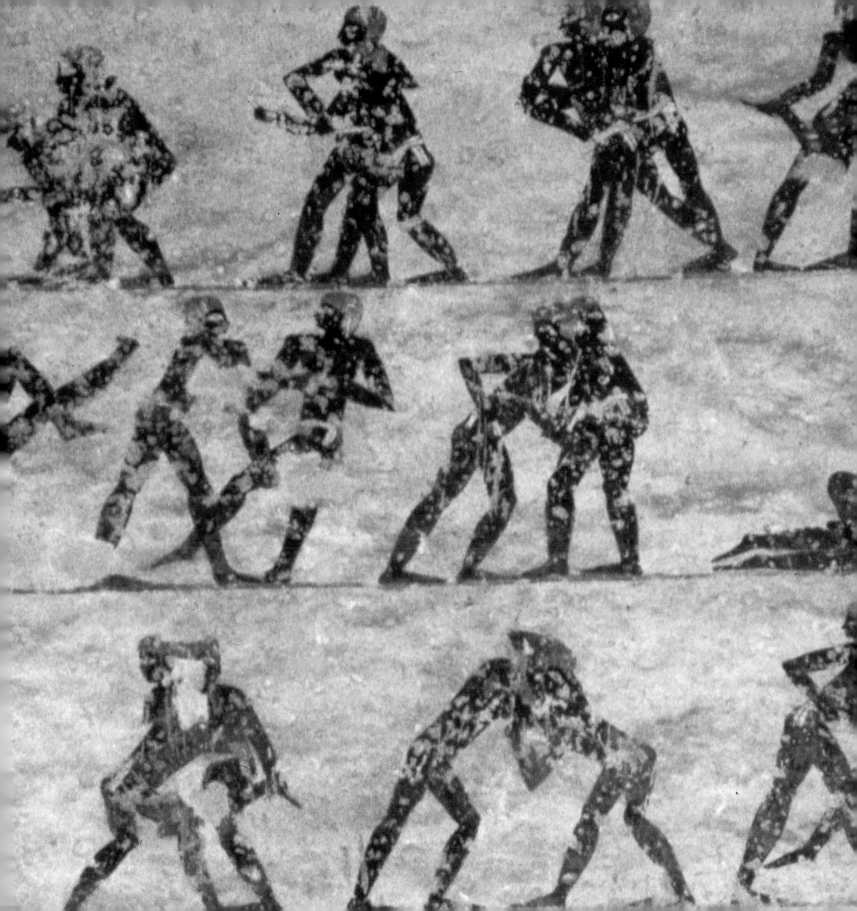

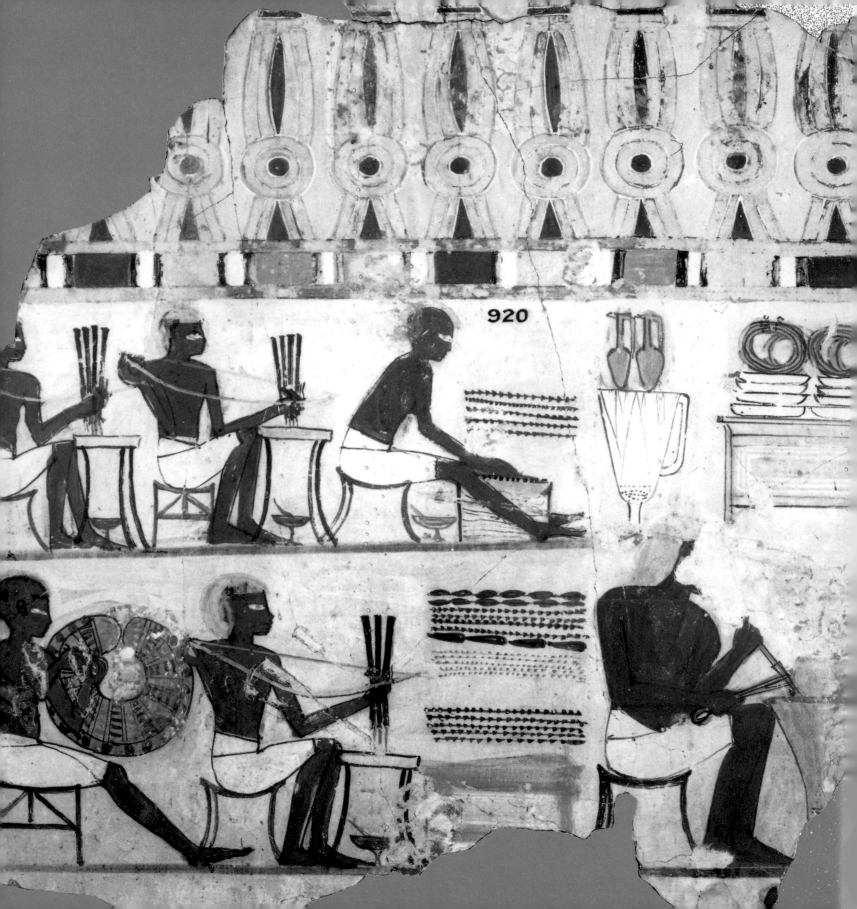

920

Some Theban tomb painters of the 18th Dynasty also showed a healthy appetite for extending the boundaries in portraying the minutiae of Egyptian life. A fragment from the tomb of Sobekhotep—a civil administrator from a district near Cairo, whose duties eventually brought him to the court of Thutmosis IV in Thebes—provides a fascinating look at jewelers and metalworkers in the process of making beads and other precious objects.

Although laid out in formal manner, the figure painting style is more relaxed and quite as charming as many other such scenes in other tombs of the same period. Three craftsmen (and most of a fourth) are depicted using bow-driven drills to make red (probably carnelian) stone beads, strings of which are displayed—along with silver and gold vessels—in both registers of the painting. A fifth jeweler is shown assembling an ornate collar, another can be seen using a long-stemmed pipe to heat charcoal in an open brazier, while a sixth appears to be involved in manually polishing beads on a wooden block.

◄ JEWELERS

A FASCINATING GLIMPSE INTO THE WORLD OF JEWELERS AND METAL-WORKERS, FROM THE THEBAN TOMB OF SOBEKHOTEP, WHOSE TITLES INCLUDED THAT OF MAYOR OF THE SOUTHERN LAKE AND THE LAKE OF SOBEK AND WHO SERVED UNDER THUTMOSIS IV. IN THE UPPER REGISTER, TWO MEN USE BOW-DRIVEN MULTIPLE DRILLS TO CREATE STONE BEADS, PROBABLY OF CARNELIAN, WHICH A THIRD POLISHES ON A WOODEN BLOCK. THE FIGURE ON THE LEFT OF THE LOWER REGISTER ASSEMBLES A DECORATIVE COLLAR FROM A VARIETY OF MATERIALS. ON THE RIGHT, WORKERS CAN BE SEEN USING BLOWPIPES TO STOKE THEIR CHARCOAL FIRES, THEIR SILVER AND GOLD PRODUCTS DISPLAYED ABOVE THEM.

► NEBAMUN THE HUNTER

THE MASTERPIECE MURAL OF NEBAMUN HUNTING BIRDS IN THE REEDS, HIS RETRIEVER
CAT ALMOST LOST IN THE RIOT OF BIRDS AND BUTTERFLIES WHICH TAKE TO FLIGHT IN
A VAIN ATTEMPT TO EVADE CAPTURE. IN HIS RIGHT HAND, THE SCRIBE HOLDS THREE
DECOY HERONS. IN HIS LEFT, A SNAKE-HEADED THROWING STICK IS READY TO STRIKE.

But the real treasure-house of the everyday – certainly as far as London's British Museum's collection of murals is concerned – was the tomb of an official who probably served as a scribe and counter of grain (tax-collector?) in the court of Amenophis III. It is generally accepted that his name was Nebamun, but whoever and whatever he was, he employed real genius in laying out and painting a series of scenes of unmatched virtuosity and flair.

The major work in this series is the bird-catching half of a double scene that would have shown the tomb-owner spearing fish. But the surviving portion is so rich in detail, color, and design that it can be viewed as an masterpiece in itself. Nebamun is shown standing on a papyrus boat among the reeds of a marsh. Beneath him, in the water, superbly detailed fish swim placidly, though the tip of a fishing spear (from the lost half of the painting) is poised ready to strike.

Nebamun, who is wearing a short hunting kilt, is accompanied by two women (his wife and daughter?), but they—and he—are simply overwhelmed by the riot of action around them as a veritable crowd of different varieties of birds and butterflies take to the air, each of them depicted with glorious accuracy and vivid colors. So crowded is the scene, it may be a while before one notices Nebamun's cat—employed as a retriever—in the midst of the melee, mouth clamped on one bird, claws grasping two others.

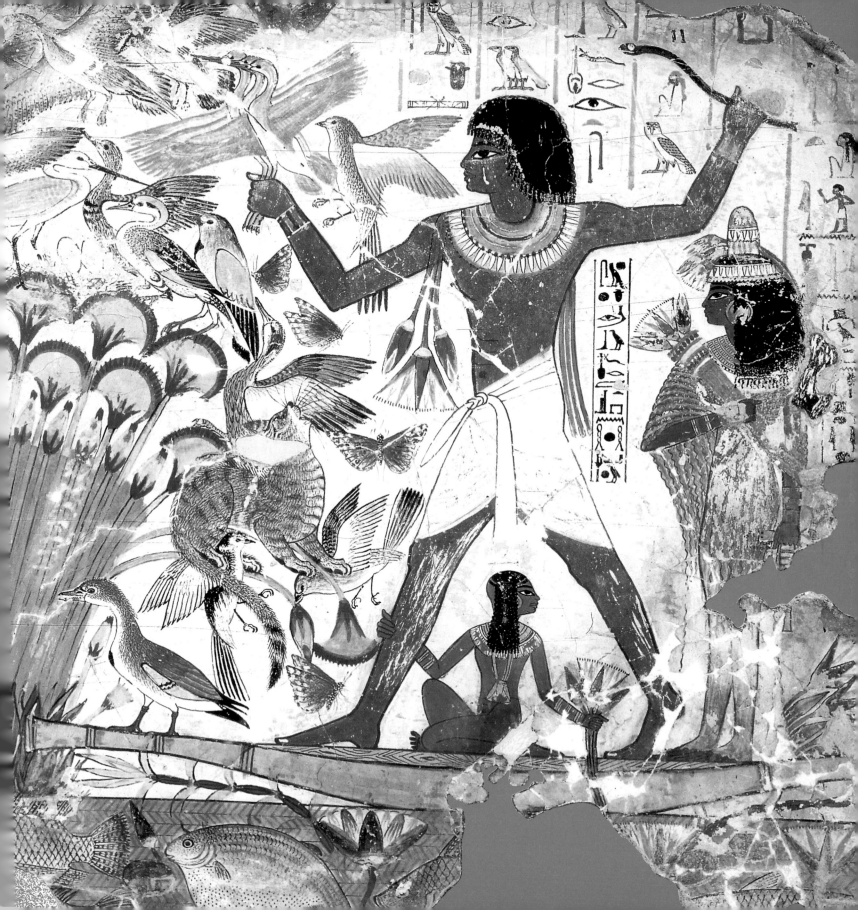

Nebamun's tomb also boasts three marvelous banqueting scenes. Again, they are full of exquisite and fascinating detail—in one, two women are engaged in conversation, with one offering the other a lotus blossom to smell; in another, musicians play lutes and a flute to entertain the guests; in a third, two almost naked girls writhe in a sensual dance while four others are providing musical and rhythmic accompaniment, one playing a double flute, the others clapping.

In a bold break with custom, the artist decided to portray two of the women full-face, the strands of their wigs in disarray. In so doing, he managed not only to depict the movement and excitement of their performance, but clearly suggests that they were shaking their heads from side to side.

Details of Nebamun's working life were also depicted on the walls of his tomb—most especially in separate scenes which portray him supervising the inspection and census of cattle and geese. While the figures of scribes and peasants are finely drawn, even greater attention has been paid to those of the animals. No two cows are painted the same, so the variety of dapples, mottles, and other markings displayed are as fascinating as they are realistic. In the goose census scene, each bird has been given the same courtesy of detail.

▶ BANQUET SCENE

THE LOWER REGISTER OF NEBAMUN'S BANQUETING SCENE IS FASCINATING FOR THE NATURALISTIC TOUCHES WHICH HELP BRING IT VIVIDLY TO LIFE. THERE IS NO MISTAKING THE SENSUALITY OF THE DANCE WHICH THE TWO SCANTILY-CLAD GIRLS ARE PERFORMING (RIGHT), BUT THE MOST DRAMATIC BREAK WITH FORMALITY IS THE PORTRAYAL OF TWO FEMALE MUSICIANS—ONE PLAYING A DOUBLE FLUTE, THE OTHER CLAPPING HER HANDS IN TIME—FULL-FACE, AND THE USE OF THE CHEERFUL UNKEMPTNESS OF THEIR WIGS TO SHOW THAT THEIR HEADS ARE BEING SHAKEN.

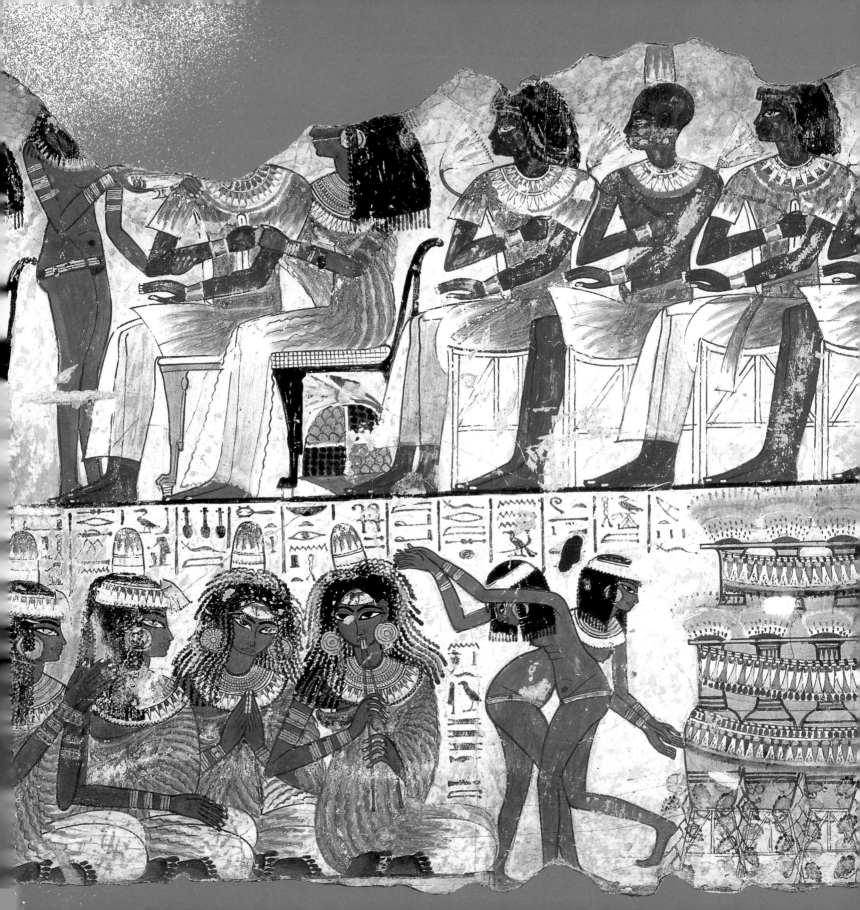

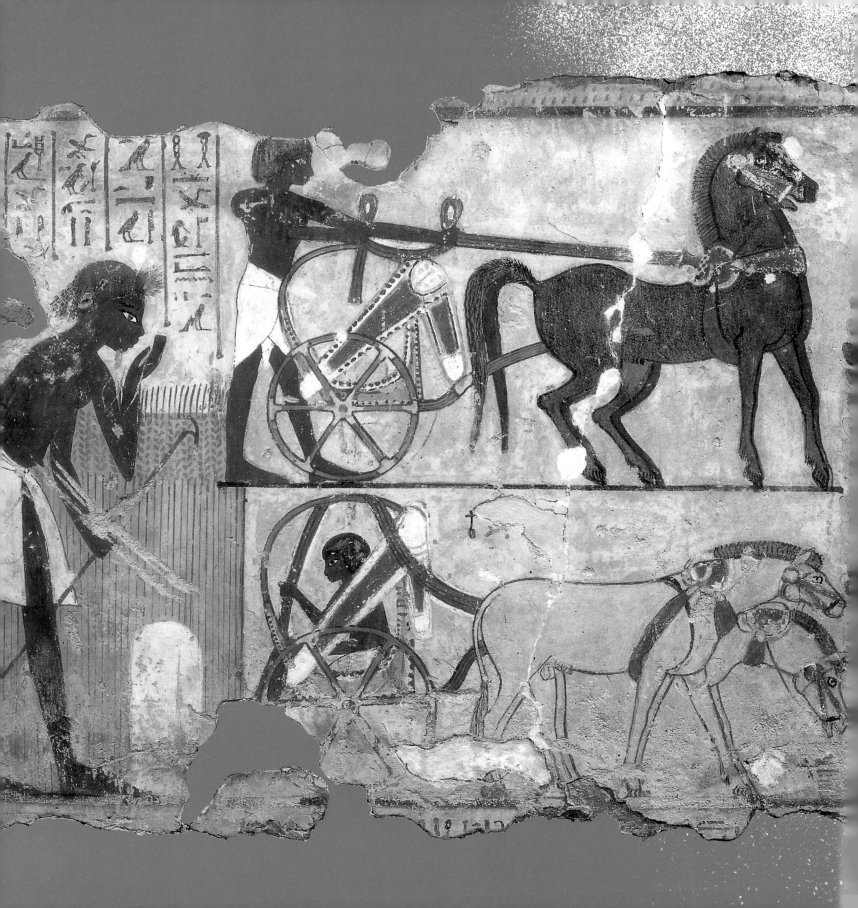

Nebamu's tomb appears to be unique however, and while there are numerous lesser works depicting the daily round in other tombs and grand homes, the principal artistic legacy of Egypt's working class lies in thè masses of sketches, test drawings, doodles, and caricatures which were found in long-abandoned villages and workplaces.

These tend, as a rule, to be on shards and fragments of *ostraca,* which are limestone flakes, or on pieces of rejected papyrus. But they do reinforce the impression that the artists of ancient Egypt were not without their own considerable talents or without a sense of humor, sometimes at the expense of their superiors.

By definition these are almost exclusively drawings. The "copy" of the Ramesses III scene mentioned in the last chapter is a case in point, but many of the remnants which have been found and preserved are of less formal and conventional subjects. The household god Bes occurs regularly, along with other votive offerings, but there are a great number of caricatures and other subjects the artist would never be asked to include in his official duties—the heads of animals (donkeys, jackals, lions, and chickens, for instance), being especially popular subjects for quick sketches, which are often superb and very realistic studies in a completely naturalistic style.

Tragically, such work can only provide us with the merest hint of what inspired the ordinary working man in his few idle moments. His standing was not considered enough to warrant recording, except in passing or when it served to reflect the glory of his lords and masters.

We are left with only a few tantalizing glimpses of the gifted masons and painters without whose skills—and sometimes genius—the ancient Egypt which so fascinates us would have remained a dust-shrouded, largely ignored, and less glorious episode in history.

In more general terms, Nebamun's tomb also incorporated paintings of the key domestic activities of hunting and gathering. In one scene men are shown bringing vegetables, barley, hares, and young deer in from the countryside. In another, a tax assessor views the crops on Nebamun's estate—a relatively mundane situation which is immeasurably enlivened by the contrasting poses of the horses featured in the scene. In the upper section, a driver is clearly having trouble containing a feisty pair whose stance is a classic portrayal of beasts who are either shying in fright or resisting blandishments to go forward. Below them, in contrast, two other horses graze quietly and let their groom have a reflective break from his labors.

We owe a great debt to Nebamun, when all is said and done. The paintings that were found in his tomb—which he, as a scribe, may have personally designed, drawn and supervised—provide us not only with superior work of unequaled quality and detail, but "snapshots" of everyday Egyptian life which are made all the more real by the use of wit and humor and a panache which is all too rarely found in the funerary art of his, or any other period.

◄ ASSESSING CROPS

MORE FROM NEBAMUN'S TOMB: A SCRIBE IS SHOWN (LEFT) ASSESSING ESTATE CROPS FOR TAX PURPOSES. THE STUDIES OF HORSES ALONE MAKE THIS A SUPERIOR PAINTING. IN THE UPPER REGISTER A FLIGHTY CHESTNUT AND A GRAY-BLACK BEAST NEED A TIGHT, CONTROLLING REIN, WHILE THE ONAGARS—A DOMESTICATED SPECIES OF WILD ASS—QUIETLY SHARING THEIR GROOM'S BREAK (ONE FROM A BASKET) IN THE LOWER REGISTER, HAVE THEIR OWN QUIET DIGNITY.

► DESERT HUNT

(OVERLEAF) THE THRILLS OF A DESERT HUNT ARE BRILLIANTLY CAPTURED IN THIS COPY OF A SCENE PAINTED ON TUTANKHAMEN'S BURIAL CASKET.

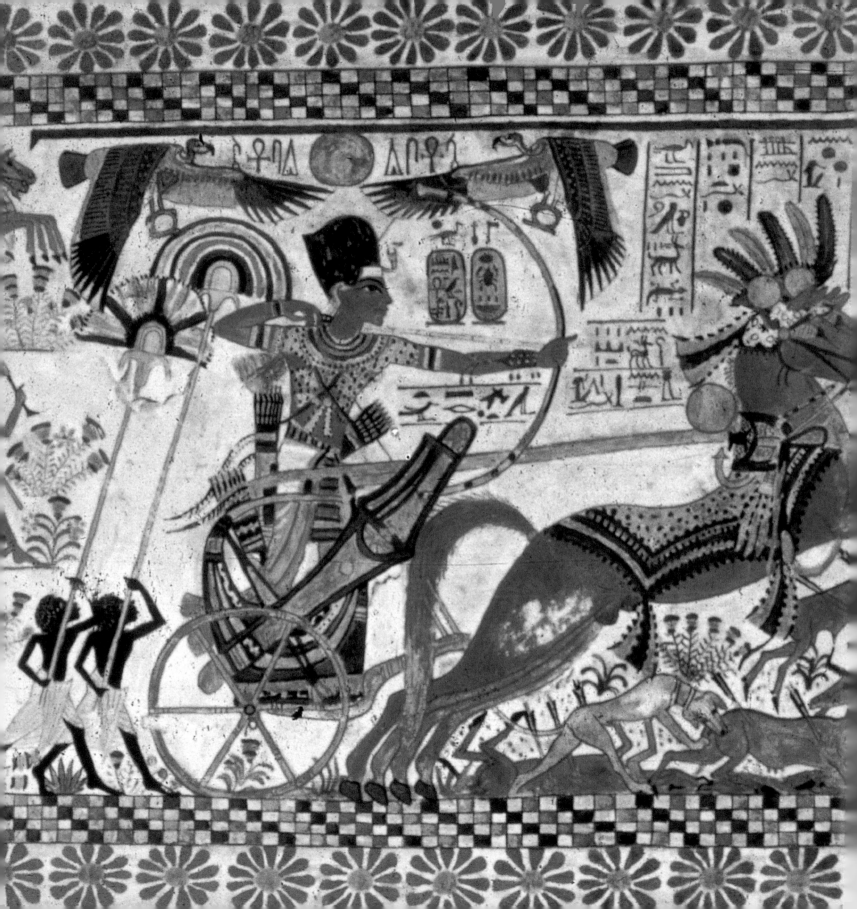

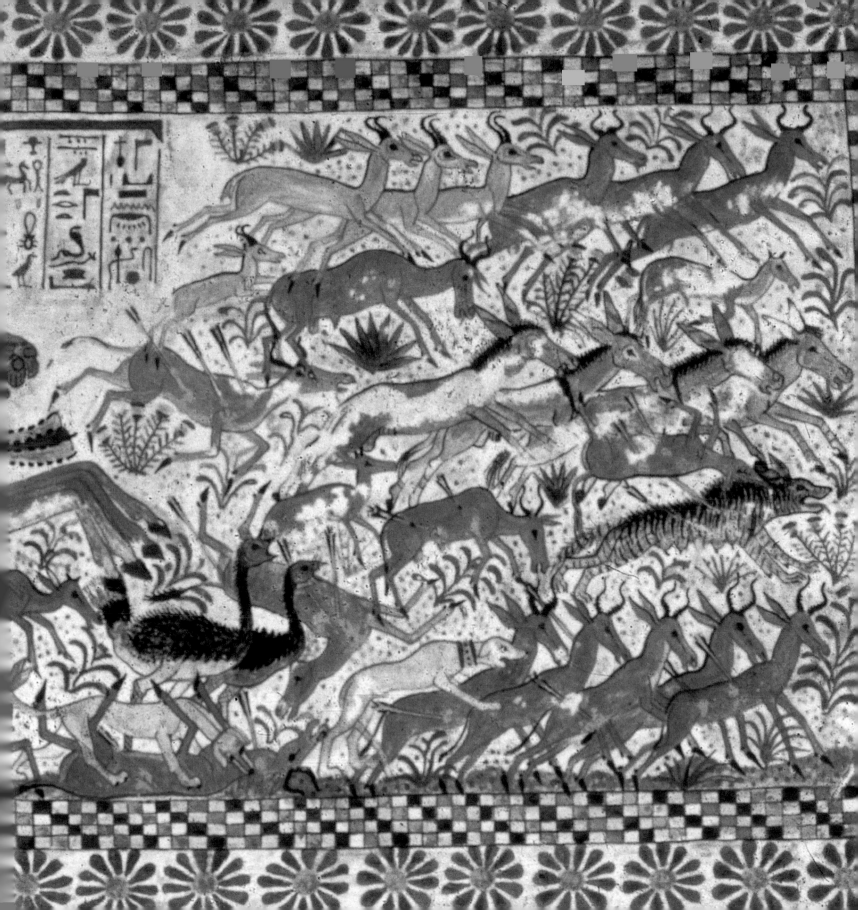

	DYNASTY	PERIOD	CAPITAL	NOTABLE RULERS
EARLY DYNASTIC PERIOD (3000 – 2770 B.C.)	1st	3000 - 2000 B.C.	Abydos (Thinis) Upper Egypt	Narmer (Menes), Aha, Uadji, Udimu
	2nd	2850 - 2770 B.C.	Memphis Lower Egypt	Peribsen, Khasekhemwy
THE OLD KINGDOM (2770 – 2160 B.C.)	3rd	2770 - 2620 B.C.	Memphis	Djoser, Sekhemkhet, Sanakhte, Khaba
	4th	2620 - 2500 B.C.	Memphis	Snefru, Khufu, Redjedef (Djedefre), Khafre, Menkaure (Mycerinus), Shepseskaf
	5th	2500 - 2350 B.C.	Memphis	Userkaf, Sahure, Neferirkare, Niuserre, Unas
	6th	2350 - 2180 B.C.	Memphis	Teti, Pepi I, Pepi II
	7th and 8th	2180 - 2160 B.C.	Memphis & Abydos	Dynasties which exist in name only as this period was marked by a constant battle between rival claimants to the throne of Egypt during which time Asian forces invaded and plundered the delta region's cities.
FIRST INTERMEDIATE PERIOD (2160 – 2120 B.C.)	9th and 10th	2160 - 2120 B.C.	Heracleopolis	A continued period of turmoil and rivalry which witnessed a lack of recognized central and unifying power until 2130 B.C. when Neferkare installed a monarchy decreed as "God-given" although not divine and the king is to be "first among equals." A majority of the princes recognize his authority to commence a re-centralization of power and reemergence of all-powerful pharaohs.

	DYNASTY	PERIOD	CAPITAL	NOTABLE RULERS
THE MIDDLE KINGDOM (2120 – 1785 B.C.)	11th	2120 - 1991 B.C.	Thebes Upper Egypt	Sehertani-Antef (Sehertowy), Mentuhotep I, Mentuhotep II, and III
	12th	1991 - 1785 B.C.	Thebes	Amenemhet I, Sesostris I (Senusret), Amenemhet II, Amenemhet III, Sesostris III
THE SECOND INTERMEDIATE PERIOD (1785 – 1580 B.C.)	13th	1785 - 1745 B.C. ?	Thebes	A complete breakdown of central power with Sekhemre as only truly notable pharaoh when he married his regent and assumed most of her powers. During this period Nubia withdrew from Upper Egyptian control. Dates are questionable as this dynasty overlapped with the next and documentation is vague
	14th	1745? - 1700 B.C.	None	Only real unity experienced during this dynasty was in the Delta region under Neferhotep, who carried the protectorate to Byblos in Lebanon when, pressed by invasions by Indo-European peoples, the Hyksos (from Canaan and Ammon) seized the Delta region, introduced the horse and wheel to Egypt, and established the cult of the god Baal
	15th	1700 - 1570 B.C.?	Avaris Lower Egypt	The Hyksos Dominion
	16th	1622 - 1580 B.C.	Thebes	Kamose, Ahmose
	17th			A "phantom" dynasty which existed under Hyksos rule in Lower Egypt

	DYNASTY	PERIOD	CAPITAL	NOTABLE RULERS
THE NEW KINGDOM (1580 – 1200 B.C.)	18th	1580 - 1314 B.C.	Thebes and Akhetaten	Ahmose, Amenophis I, Thutmosis I, Thutmosis II, Hatshepsut, Thutmosis III, Amenophis II, Amenophis III, Amenophis IV, Tutankhamen
	19th	1314 - 1200 B.C.	Tanis and Thebes	Ramesses I, Seti I, Ramesses II (The Great), Merneptah, Seti II
	20th	1200 - 1085 B.C.	Thebes	Sethnakht, Ramesses III, Ramesses XI
THE THIRD INTERMEDIATE PERIOD (1085 – 716 B.C.)	21st	1085 - 950 B.C.	Tanis and Thebes	Sendes, Piankhi
	22nd (Libyan)	950 - 730 B.C.	Bubastis	Sheshonq I, Osorkon I
	23rd (Bubastite)	757 - 730 B.C.	Bubastis	Osorkon III
	24th (Saite)	730 - 716 B.C.	Sais	Tefnakhte, Bocchoris

	DYNASTY	PERIOD	CAPITAL	NOTABLE RULERS
THE LATE PERIOD (716 – 311 B.C.)	25th (Ethiopian	716 - 666 B.C.	Napata and Thebes	Piankhi, Shabaka, ShabatakA, Taharka, Tanutamon
	26th (Saite)	666 - 524 B.C.	Sais	Necho, Psamtik I, Necho II, Psamtik II, Psamtik III, Cambyses
	27th	524 - 404 B.C. (Persian)	Sais and Memphis	Cambyses, Darius I , Darius II
	28th	404 - 398 B.C.	Sais	Amyrtaeus
	29th	398 - 378 B.C.	Mendes	Nephritis I, Achoris
	30th	378 - 311 B.C. (Sebbenyte)	Sebennytus and Memphis Alexandria	Nectanebo II, Kabbas, Darius III, Alexander the Great, Philip Arrhidaeus, Alexander Aegos
THE GRAECO-ROMAN PERIOD (332 B.C. – 323 A.D.)	Ptolemaic	305 - 30 B.C.	Alexandria	Ptolemy I , Soter, Ptolemy II Philadelphus Ptolemy III Everegetes, Ptolemy IV Philopator, Ptolemy V Epiphanes, Ptolemy XIII, Cleopatra VII

ACKNOWLEDGMENTS

AKG London 26/27, 32/33, 46/47,/Erich Lessing 18, 28/29, 30, 31, 32 left, 36/37, 38, 39, 41, 49, 50/51, 54, 55, 56/57, 58/59, 60/61, 64, 65, 66/67, 70/71, 72/73, 73 top centre, 74, 74/75, 78/79, 79 right, 80, 81; **Bridgeman Art Library**/British Museum 17, 19, 34/35, 90/91,/Giraudon 2, 24, 25, 40, 42/43, 44, 45, 68, 69,/Lauros-Giraudon 16; **British Museum**, 20/21, 22/23, 42 left, 52/53, 57 right, 62, 63, 82/83, 84/85, 86/87, 88/89; **Werner Forman Archive** 76, 77; **Griffith Institute, Ashmolean Museum, Oxford** 4/5, 12/13; **Robert Harding Picture Library** 2/3, 10/11; **Image Bank**/Guido Alberto Rossi 8/9; **Shire Publications Ltd**/*Tutankhamen's Egypt*/Robert Dizon 2/3 map.